CAPE COD
SHORE WHALING

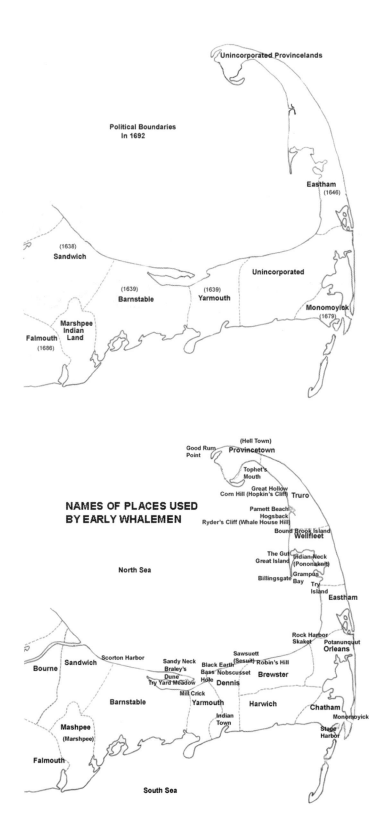

Unincorporated Provincelands

Political Boundaries
In 1692

Eastham
(1646)

(1638)
Sandwich

Unincorporated

(1639)
Barnstable

(1639)
Yarmouth

Monomoyick
(1679)

Marshpee
Indian
Land

Falmouth
(1686)

NAMES OF PLACES USED
BY EARLY WHALEMEN

Good Rum
Point

(Hell Town)
Provincetown

Tophet's
Mouth

Great Hollow
Corn Hill (Hopkin's Cliff) Truro

Pamett Beach
Hogsback
Ryder's Cliff (Whale House Hill)

Bound Brook Island
Wellfleet

North Sea

The Gut
Great Island
Indian Neck
(Pononaknit)

Grampus
Billingsgate Bay
Try
Island
Eastham

Rock Harbor
Skaket
Potanunquut
Orleans

Scorton Harbor

Sawsuett
(Sesuit) Robin's Hill

Sandy Neck
Braley's
Dune
Try Yard Meadow

Black Earth
Bass Nobscusset
Hole

Brewster

Bourne Sandwich

Mill Crick

Dennis

Barnstable Yarmouth Harwich Chatham

Indian
Town

Monomoyick

Mashpee
(Marshpee)

Stage
Harbor

Falmouth

South Sea

CAPE COD
SHORE WHALING

AMERICA'S FIRST WHALEMEN

JOHN BRAGINTON-SMITH & DUNCAN OLIVER

Charleston London

History
PRESS

Published by The History Press
Charleston, SC 29403
www.historypress.net

Cover design by Marshall Hudson.

All images courtesy of the author unless otherwise noted.

First published 2008

Manufactured in the United Kingdom

ISBN 978.1.59629.429.5

Library of Congress Cataloging-in-Publication Data

Braginton-Smith, John.
Cape Cod shore whaling : America's first whalemen / John Braginton-Smith
and Duncan Oliver.
p. cm.
Includes bibliographical references and index.
ISBN-13: 978-1-59629-429-5 (alk. paper)
1. Offshore whaling--Massachusetts--Cape Cod Bay--History. I. Oliver,
Duncan. II. Title.
SH383.2.B73 2008
639.2'8097449--dc22
 2007047728

Notice: The information in this book is true and complete to the best of our knowledge. It is offered without guarantee on the part of the author or The History Press. The author and The History Press disclaim all liability in connection with the use of this book.

To Carol—

Your patience, understanding and willingness to listen and suggest ideas

made this revised edition possible.

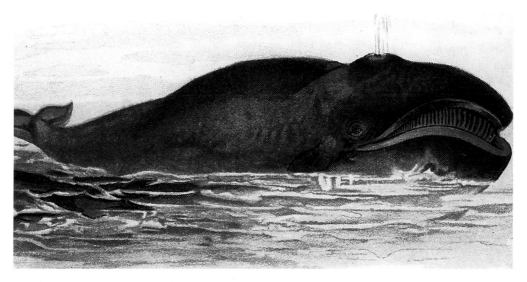

Nineteenth-century Greenland whale, also known as a right whale.

CONTENTS

ACKNOWLEDGEMENTS

It would have been impossible to complete our research without the help of many different people. These include Historical Society of Old Yarmouth members Dot Henion, Stuart Baker, Barbara Ryan, Pat Tafra and Ruth and Ted Weissberger. We wish to thank the many town workers in the town clerk offices at Sandwich, Barnstable, Yarmouth, Dennis, Harwich, Brewster, Orleans, Wellfleet, Truro and Provincetown, especially Barbara Gill of Sandwich archives. Ned Handy of Barnstable Historical Society, Bobbie Cornish of Eastham Historical Society, Libbie Oldham and Marie (Ralph) Henke from Nantucket Historical Association and Mary Sicchio of Nickerson Room at Cape Cod Community College Library were very obliging and helpful. Several museums and their staff were of assistance, including Britta Karlberg from Peabody Essex Museum, Lisa Blair and Rob Stewart from Trayser Museum and especially the New Bedford Whaling Museum—Michael Dyer, librarian at the Kendall Institute, and his assistant, Laura Pereira. Chris Lundquist and Lucy Loomis of the Sturgis Library were of assistance, as were Eileen Krauss of the Harwich-Brooks Library and the staff of the Yarmouth libraries. The staff members of the Massachusetts State Archives were especially knowledgeable and willing to point out other areas to search, as was Hope Morrill, archivist for Cape Cod National Seashore. Thanks go to Charles Smith for genealogical help, author Judith Lund, Virginia Adams, Dick Weckler, Sally White, Ben Muse and Craig Converse.

Several people read drafts and gave valuable suggestions, including Dot Henion, Ed Zabloski, Ben Muse, Richard Weckler, Mary Sicchio, Ted and Ruth Weissberger, Matt MacKenzie and Michael Dyer. Ted Weissberger was especially helpful with the graphic design and layout. Many others helped with ideas and documents and we are very grateful to all of you!

INTRODUCTION

Whale oil was extremely important to the economic well-being of the colonies of Plymouth and Massachusetts Bay. Cotton Mather called whale oil "the staple commodity of the colony."[1] Yet, authors, especially those writing about Cape Cod, have barely mentioned the importance of shore whaling. Francis Baylies's *Historical Memoir of the Colony of New Plymouth*, written in 1820, stated, "During the period embraced by this chapter [1641–75], the history of Barnstable is almost devoid of interest…The history of Yarmouth is as devoid of interest as that of Barnstable."[2] Simeon Deyo and Frederick Freeman, two well-known nineteenth-century Cape writers, vastly underrated shore whaling.

Some authors downplayed primary source material. Charles Boardman Hawes, in his book *Whaling*, written in 1924, noted, "But most of the old statutes are similar…and except for their remarkable spelling, which soon becomes tiresome they make dull reading. Having little to do with active whaling, they need not concern us."[3] William Langdon wrote in 1937, "Before the eighteenth century this [whale fishing] was mostly incidental, consisting of catching and killing whales which drifted into shallow water at low tide."[4]

Herman Melville didn't help with his novel *Moby Dick*. He stated that Nantucket was the place where the first dead American whale was stranded. That was his total acknowledgement of shore whaling.

In 1915, the State Street Bank and Trust published *The Whale Fishery of New England*. Its section on "Early New England Whaling" contained five factual errors in the first two paragraphs! This important early industry has faced hard times with historians.

The authors have searched out every primary source available, to give the truest and clearest picture of shore whalemen of Cape Cod. They hope the result will be a new appreciation for this little-known part of colonial history. Their conclusions agree with author Clifford Ashley, who summed it up best when he wrote, "The Cape Codder was the first to attempt this fishery sporadically. The Long-Islander deserves the full credit for first making it an organized business. But to the Nantucketer will always be the glory of having founded a great national industry."[5]

BACKGROUND INFORMATION

Most historians agree that Basques in Europe began whaling prior to the tenth century. A Danish work declared that Icelandic whalemen were whaling by the middle of the twelfth century.[6] The twelfth and thirteenth centuries were high points, as Europeans ventured offshore in small boats and harpooned right whales.[7] These were hauled to shore, where the blubber was removed and tried for oil. As whales grew scarce, this fishery extended to the Newfoundland Banks, north of Nova Scotia. No European whalemen[8] are known to have ventured as far as Cape Cod on a regular basis.

In 1612, England's King James petitioned the Spanish crown to allow Basques to come to England and teach whaling. The first British whaling fleet had six Basque officers under contract. The Dutch also recruited Basques."[9]

Explorers, including Bartholomew Gosnold,[10] John Smith and Samuel de Champlain, saw whales in Maine and Massachusetts waters. Captain John Smith, of Pocahontas fame, carried a permit from the king to fish for whales when he sailed in 1614. Some authors suggest that the *Mayflower* itself was used as a whaleship,[11] although this fact doesn't appear to be true.

From the first day of the arrival of the *Mayflower* to Massachusetts, whales became part of the Pilgrims' lives. As their vessel lay moored in Provincetown Harbor, whales were visible.

> *And every day we saw whales playing hard by us; of which in that place, if we had instruments and means to take them, we might have made a very rich return, which to our great grief we wanted. Our master and his mate, and others, experienced in fishing, professed we might have made three or four thousand pounds worth of oil. They preferred it before Greenland whale-fishing, and propose the next winter to fish for whale here.*[12]

The Pilgrims explored in small boats while anchored in Provincetown Harbor, and saw Indians cutting up beached blackfish at Wellfleet Harbor. Pilgrims called this "Grampus Bay," grampus being another name for blackfish or pilot whale.

Whales were very important to early settlers.[13] Early sightings include one from Richard Mather, who wrote that he had seen "mighty whales spewing up water in the air like the smoke of a chimney, and making the sea around them white and hoary."[14] In 1635, Governor John Winthrop reported drift whales that were "cast on shore."[15]

Colonists used whaling methods that had been established centuries earlier. The earliest whaling in America was done by chance. People responded to strandings, and soon lookout stations were set up to watch for these whales, known as drift whales. Provincetown was considered for permanent settlement by the Pilgrims because of the whales there.[16]

It is hard to date the first shore whaling venture. Whaling from small boats had been taking place long before the colonization of America. A 1582 engraving by Johannes Bol showed small boats hunting whales near shore in Newfoundland. There were various numbers of people in the boats, some with the harpooner standing near the middle.

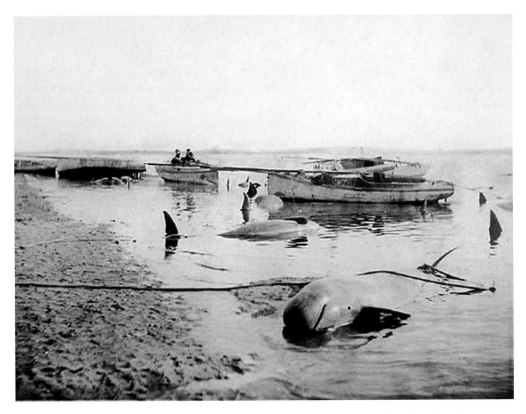

Picture of blackfish ashore in Wellfleet in 1910. *Courtesy of Sturgis Library, Barnstable, Massachusetts.*

American colonists would have done the same when whales came near to shore, rather than wait patiently for them to beach themselves.

How early? With Cape Cod towns having more than two hundred souls by the early 1640s and whale oil being a staple for lighting in homes, men would have used their watercraft to hunt whales. While author Randall Reeves felt shore whaling may have started as early as the 1620s or '30s, that date may be a bit too early. Cape Cod town records do not start until the 1650s, and by then shore whaling was firmly entrenched. A date of 1640 seems reasonable for the first shorewhaling venture. Standardization of the process, however, would have to wait until 1680, when Jacobus Loper came to Barnstable.

The first mention of whales in an official document occurred in 1628. The charter for the Massachusetts Bay Company stated, "And free libertie of Fishing in or within any of the Rivers or Waters within the Boundary and Lymytts aforesaid, and the Seas thee unto adjoining; and all Fishes, Royal Fishes, Whales, Balan, Sturgions or other fishes of what Kind or Nature so ever, that shall at any hereafter be taken in or within the saide Seas or Waters. Registered 18 March 1628."

Drift whaling on Cape Cod is mentioned as early as 1635, before any towns on the Cape were established. John Winthrop, governor of the Massachusetts Bay Colony,

wrote in his journal in 1635, "Some of our people went to Cape Cod, and made some oil of a whale, which was cast on shore. There were three or four cast up, as it seems there is almost every year."[17] To write "almost every year," one must look back two years or more. It seems probable that people from Massachusetts Bay Colony had known of these whales almost as soon as they arrived in 1630.

The question arises as to who first obtained oil from whales in what is now the United States. There can be no doubt that Indians took advantage of drift whales long before the Europeans arrived, but it was almost exclusively for food. Trying the oil and using the oil and whalebone for economic advantage in the New World started with the arrival of the Europeans.

The Dutch on Long Island, who started their colony in 1625, knew of whales and took advantage of them. A surprising amount of travel existed between the colonies of New Amsterdam and those of Plymouth Colony and Massachusetts Bay. Aptucxet trading post, built in 1627, welcomed traders from all colonies. It was located on Buzzards Bay in what is now the town of Bourne. At this post, information and goods passed back and forth. Unfortunately, no record indicates whale oil or bone used as trade items. The post survived until 1660.

Joshua Barnes, a founder of Yarmouth, is a good example of an early traveler between colonies.[18] He came to Plymouth in 1632 as an indentured servant to a shipwright. In 1639 he was a founder of Yarmouth. By 1646, he had moved to Edgartown on Martha's Vineyard, and three years later he was a resident of Southampton, Long Island. While called a planter, in the winter months he was involved in shore whaling. Knowledge of whalemen from Long Island could have come from people such as Joshua Barnes.

Southampton, New York, was settled by men from Lynn (Massachusetts Bay Colony) in 1640; that same year, men from Lynn settled on Cape Cod. Easthampton was founded in 1649 by nine people from Lynn. Both towns were part of the colony of Connecticut. Almost immediately they set up whaling lookouts along the south shore of Long Island. The town of Southhampton (Long Island) divided itself into four wards of eleven persons each; they took turns cutting up drift whales; profits were shared by every inhabitant along "with his child or servant above sixteen years of age, those performing the labor to receive an extra share."[19] This was the first official action by any town or colony directly related to shore whaling.

Whaling was also taking place along the shores of Cape Cod. While towns didn't formalize the procedure until later, it didn't take long for lookouts to be set out to watch for stranded whales. Whalemen from Massachusetts and Long Island teamed up to whale along the North Carolina coast as early as 1666, only a short while after the English took over the Dutch colony of New Amsterdam and renamed it New York.[20] There are many other instances of New Englanders hunting whales all along the Eastern seacoast.

The period was one of great upheaval in England and Europe, as well as in the colonies in New England and New Amsterdam (later New York). It's understandable that whaling efforts didn't receive great publicity.

To fully understand the beginnings of whaling in Plymouth Colony and the conditions under which it grew, the founding of towns on Cape Cod must be explained. Plymouth

Colony's charter didn't allow it to incorporate new towns. Massachusetts Bay Colony, founded ten years after Plymouth, had this authority in its charter and grew much more rapidly.

The first few years in Plymouth were difficult for the new settlers. Thirty-five additional settlers arrived in 1621, and sixty-seven in 1622. Early settlers of Plymouth had little experience with fishing and hunting, and weren't very adept at farming. One author wrote, partly with tongue in cheek, "These were people united by their religious zeal…and their greatest food-gathering skill in the early years seems to have been an ability to find huge food caches hidden away by native tribesmen."[21] Finding drift whales required more luck than expertise.

Colonists had been using Cape Cod for drift whaling during winter months almost since their arrival. They came from both Plymouth and Massachusetts Bay Colonies. In 1637, colonists received official permission from Plymouth authorities to settle on Cape Cod. Because of travel problems, these unincorporated settlements were allowed to send representatives, called deputies, to the General Court at Plymouth. This legislative body met quarterly. Deputies were first sent from Sandwich and Yarmouth in June 1639. Barnstable's were sent in December of 1639.

In 1641, Plymouth allowed three Cape men, one each from Sandwich, Barnstable and Yarmouth, to hear cases and act as a local court. Plymouth required each township to appoint two deputies, and each township had to have a clerk, treasurer, constable and highway supervisor. A meeting of the male inhabitants had to take place to choose these people; this was perhaps the origin of the town meeting.

In1651, nearly a dozen years after the initial settlement, Plymouth allowed Sandwich the right to have four men call town meetings, the "selectmen" of the town. It would take ten more years before all towns on the Cape had selectmen. It was at this point that town records began being kept.

In 1658, the General Court of Plymouth first proposed that serious consideration be given to hiring a schoolmaster for each township. The same act was proposed again in 1663, but it wasn't until 1670 that Plymouth finally financed schools with profits from the Cape Cod fishery.

Whales at that time were called fish, and the oil given to the colony from each whale provided much-needed income. Towns on the Cape were asked in 1674 to provide schools if eight "scholars" appeared, fourteen years after schools were first proposed for the colony. Unfortunately for history, some researchers interpreted "fish" as striped bass, not whales, and they have been given credit for starting education in America.

Since the organization of Cape Cod towns was gradual, records were slow to document whaling. Thus there are gaps in information about the first whaling in America. What is amazing is that so much information does exist. The great economic impact that whaling had on each town's economy led to local measures being put down in writing.

Times were difficult in Plymouth Colony. It failed to attract many new colonists and the colony looked for a better location for the seat of government. By 1644, the inhabitants found Plymouth too barren. They considered moving the entire government

to what would later become Eastham, but didn't act on it. Could the abundance of whales have been a reason for the thoughts of moving? It isn't said in colony records.

Events in Britain and neighboring colonies also affected development. While Plymouth mulled the possibility of moving to a better site, Britain boiled in a civil war. The war pitted royalists against Parliament. Massachusetts Bay Colony and Plymouth Colony were pro-Parliament, and the pro-Parliament forces under Cromwell defeated the royal forces in 1646. Three years later, the Parliamentarians chopped off King Charles's head. The next eleven years were tumultuous, until the monarchy was restored in 1660 with the coronation of Charles II. The new king, interested in expanding his influence, looked toward the non-English colony closest to Massachusetts—New Amsterdam.

Colonists from Massachusetts had migrated to Long Island and Connecticut in the 1630s. The eastern end of Long Island had become more English than Dutch. Indian problems and a very vulnerable position made New Amsterdam ripe for annexation. Charles II arranged with his brother, the Duke of York, to take over the Dutch colony. In 1664, without a fight, New Amsterdam became the colony of New York. While New Netherlands reverted back to the Dutch briefly in 1673–74, it remained a colony very interested in whaling.

Indian relations were a problem in Connecticut, Long Island and Massachusetts. The Pequot War against Indians in Connecticut in 1637 hit close to home, as many colonists there had originally come from Massachusetts. In 1675, the most destructive war in New England's history took place. King Philip's War pitted the Narragansett Indians and their allies against European settlers. One-sixth of all males in Massachusetts were killed; twenty-five towns were destroyed. Even though Indians on the Cape remained loyal to the Plymouth government, distrust abounded. The historical records for this period are less complete, including records involving whaling.

King Charles II died in 1685 and his successor, James II, approved a reorganization of the Northern colonies. In response to the New England colonies' resistance to some Navigation Acts, the colonies were placed under direct rule of the Crown. Colonial charters were revoked and the Dominion of New England was created in 1686, with Governor Edmund Andros representing the Crown. As a result, no Plymouth government existed from October 15, 1686, to June 4, 1689. This meant no records as well.

There was no representative assembly under Andros, as he and his councilors made laws and collected taxes. When towns complained, town meetings were curtailed. This infuriated New Englanders. Historians, having no records to utilize during the Andros period, have relied on Hutchinson's *History of Massachusetts Bay* for information.

Plymouth was divided into three counties. Each had a registry of deeds, courts and a treasurer. Records from this point on were held primarily at the county level.

The Dominion of New England lasted for three troubled years. Andros was an Anglican, while Massachusetts Bay and Plymouth were Puritan/Pilgrim. Many colonists had left England to escape the pressure of the Anglican Church.

Curiously enough, economic issues such as who was the rightful owner of harpooned whales continued to be problems. In 1688, legislation was passed that "each company harping Iron & lance be Distinctly marked on ye heads & sockets with a poblick mark; to ye prevention of strife."[22]

In England, feelings swelled against James II. Parliament openly sought William of Orange and his wife Mary (daughter of James II) to be king and queen.

Andros's reign came to an end on April 18, 1689. Andros was forced to abdicate after a "rebellion" succeeded without firing a shot. Even a British warship, the HMS *Rose*, a seventy-four-gun ship of the line stationed in Boston, was incapacitated by having its sails taken from it by colonial militia! All of this was done three days before there was official notification that James II had been overthrown. James II's removal was called the Glorious Revolution in Britain. James II took refuge in France, further damaging relations between these two major powers.

Plymouth Colony now found itself in a state of limbo; was it independent or was it to become part of another colony? In June 1690, the British decided that Plymouth would be joined to New York. Only intervention by Reverend Increase Mather got the British government to make it part of Massachusetts Bay instead.

A new charter was drawn up in 1691 that incorporated Massachusetts Bay and Plymouth Colony. Under this charter, Plymouth citizens could choose representatives to the General Court, but the king chose the governor, lieutenant governor, secretary and officers of the admiralty.

The Salem witchcraft trials took place the year following this new colonial charter, and wars with France were to continue intermittently for the next seventy years. Can there be any doubt why whaling didn't monopolize the records?

RESEARCH PROBLEMS

The use of the phrase "Cape Cod" to describe the entire peninsula did not come into general usage until after shore whaling was past its glory days. What is known today as Provincetown was called Cape Cod, and whaling documents often refer to it this way—"awhaling at Cape Codd." When Provincetown became a separate town in 1727, the new name slowly became part of the language.

Another research problem involved identifying names of locations used by the whalemen and other contemporaries. These vary from land features such as "Hogback" (in present-day Truro) and "Black Earth" (the northside beaches in Dennis), to names given to bodies of salt water.

Mapmakers were not always familiar with the area. They often identified places far from their true locations. For instance, a 1704 map by Jeremiah Seller and Charles Price placed Billingsgate near Sandwich, even though its true location is across the bay in Wellfleet.[23]

Names of saltwater bodies of water followed those given by inhabitants of the area. From earliest times, people from the Cape called Cape Cod Bay the "North Sea" and Nantucket Sound the "South Sea." These were written on maps as early as 1676.[24] Massachusetts Bay was split on early maps. The area south of Manomet Point in the west, to Billingsgate in the east, was known as Barnstable Bay, even up to the time of the American Revolution.

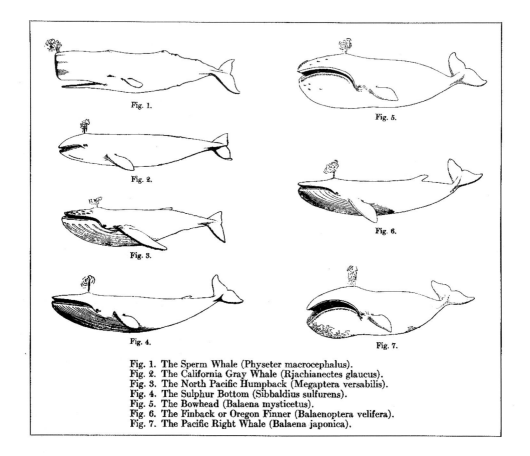

Fig. 1. The Sperm Whale (Physeter macrocephalus).
Fig. 2. The California Gray Whale (Rjachianectes glaucus).
Fig. 3. The North Pacific Humpback (Megaptera versabilis).
Fig. 4. The Sulphur Bottom (Sibbaldius sulfurens).
Fig. 5. The Bowhead (Balaena mysticetus).
Fig. 6. The Finback or Oregon Finner (Balaenoptera velifera).
Fig. 7. The Pacific Right Whale (Balaena japonica).

Types of whales. Illustrated in *Whale Fishery of New England* by State Street Trust Co., 1915. Although the book is about New England, most of the whales were from the Pacific Ocean, not the Atlantic.

Cotton Mather, in his map of Massachusetts Bay Colony, printed early in the eighteenth century, identified what is known today as Provincetown Harbor as "West Harbor."[25] All of these identities were finally standardized when Massachusetts published its first state map in 1795.

Finally, one must understand that the word "countrey" was used by residents to describe their colony, whether it was Plymouth Bay or Massachusetts Bay. With all of this as background, we can now begin our look at shore whaling.

WHALES:
OBJECTS OF THE SEARCH

The early whalemen wanted right whales. It appears they were named "right" because they were the right kind of whale to find/take. Right whales generally floated after being killed.[26] They had baleen rather than teeth. The baleen, called whalebone by colonists, was used for many things, including stays and other fasteners in clothing.

Right whales have been known by many names. They were the whales hunted by the Basque, Biscayan, English, Dutch and Icelandic whalemen. Early Europeans sometimes called this whale a "nordcaper" or "noordkaper." Some had white spots on various parts of the body, especially tips of the flukes and the bonnet on the snout. These were areas infested by parasites, a possible cause of the coloration.[27]

To colonists in the 1600s, right whales also were called whalebone whales because of the amount of their baleen. The word "right" was used to distinguish this whale from finbacks and humpbacks. It was also known as a black whale, because of its color, as well as a scrag, brod back, North Atlantic right whale, baleine de Biscaye, Biscayan right whale and Greenland whale.[28]

The right whale was easily identified from a distance. It had two spout holes that made a forked spout, distinguishing it from other whales.[29] The bushy spout could rise fifteen feet.[30] Right whales came closer to shore than most other whales, and during the winter season sometimes were found in tidal waters.

The first whale killed in Nantucket harbor was called a scrag by locals. In 1725, Paul Dudley stated that a scrag was nearest to the right whale both in figure and in quantity of oil. According to the U.S. Fisheries Report of 1884, the scrag whale was akin to a finback, although it had a half-dozen knobs or bumps on the back rather than a fin. The opinion of many whalemen was that the scrag was not a distinct species, but a right whale that lost its mother while young and grew up without parental care.[31]

Humpbacks did not come as close to shore. Their baleen was shorter, and was good only to make buttons.[32] Humpbacks had another serious drawback when killed at sea. They usually sank for up to two days, and this caused many disputes as to who owned

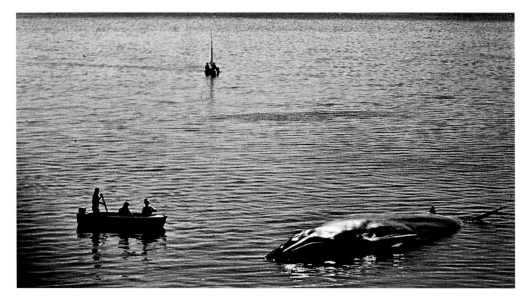

Postcard picture of a sixty-one-foot finback whale in Wellfleet Harbor. No date is given on the postcard, but it appears to be 1960s. Finbacks were the most common large whale to come ashore.

the dead whale. Humpbacks were called bunch whales by Europeans.[33]

Sperm whales lived farther out to sea. They had teeth, could dive deeper and were more aggressive with their jaws.[34]

Finback whales were the most common whale to strand themselves.[35] However, finbacks were harder to kill in open water, as they swam faster than other whales. Further hurting their value was the fact that they yielded less oil and contained less whalebone.

There were vast numbers of whales in Cape Cod Bay during certain times of the year. NOAA estimated that at one time there were more than seven thousand of them.[36] Ezra Stiles recorded in his diary in 1762 that Captain Atkins, a Truro man about sixty years old, told him "he had seen as many whales in Cape Cod [Provincetown] harbor at one time as would have made a bridge from the end of the Cape to Truro shore, which is seven miles across and could require two thousand whales." [37] Captain Atkins must have seen these as a young man, for whales were becoming scarce by 1715.

A main reason for hunting whales was to obtain whale oil, frequently spelled "oyle." The oil, sometimes called train oil,[38] was produced by trying the oil from the blubber. Oil was used for lighting as well as tanning of leather and lubrication.[39] Baleen was used in clothing for stays, buttons and stiffeners, and in the arts.[40]

Contemporary sources provide good accounts of the amount of oil that could be obtained from a whale. In 1708, Governor Cornbury of New York wrote to the Board of Trade in England, "a Yearling will make about forty barils of Oyl; a Stunt or Whale two years old will make sometimes fifty, sometimes sixty Barrils of Oyl; and the largest whale that I have heard of in these Parts, yielded one hundred and ten barrels of Oyl, and twelve hundred Weight of Bone."[41] Some researchers believe the estimates are too

liberal and estimate an average yield per whale of 44 barrels of oil and 647 pounds of baleen.[42]

In 1725, Paul Dudley of Massachusetts Bay wrote an essay on the "Natural History of Whales," which was published by the Philosophical Society of London. In it he gave amounts of oil obtained from whales, as well as the colloquial words used by whalemen to identify the whales.

> *At birth the calf is about 20 ft long, and of little value, but then the dam is very fat. A yearling, called a short head and very fat, about 50 barrels. The dam at this time is very poor called a dry skin, and yields less than 30 barrels. Two year old, after weaning, called a stunt, gives 24-28 barrels. Over two years old is called a skull fish. Maximum size 60-70 ft long, baleen (bone) is 6–7 ft long; one whale can give 130 barrels of oil; tongue gives about 20 barrels. In fall of year, the Right (or whalebone) whales go westward, and in the spring eastward. Sometimes 100 in a skull.*[43]

It is interesting to note that author William Scoresby called baby right whales "suckers."[44]

Whales were also eaten. Indians prized the fin and tail as delicacies, and some ate the leaner (non-blubber) portions. For centuries, Europeans had eaten whales. During the Middle Ages, Basques brought whale meat to market as an alternative to fish on Fridays. Catholics refrained from eating flesh on lean days, "but cold foods were permitted. Because fish came from water, it was deemed cold, as were waterfowl and whale…Lean days included all Fridays [the day of Christ's crucifixion], the forty days of Lent, and various other days in the religious calendar…In total, meat was forbidden for almost half the days of the year."[45] Whale meat, often salted to preserve it, was "found good to be served with peas, and the most prized part of the whale, the tongue, was also often salted."[46] Those who ate fresh whale meat said that it was good, somewhat coarser than beef, but otherwise hardly inferior.[47]

Some whalemen ate the remains of the blubber after it had been tried. Called "crackling," some said it tasted like toasted bread.[48] Scoresby called these "fritters" and said the flesh of a young right whale "is of a red color and when cleared of fat, broiled and seasoned with pepper and salt, does not eat unlike coarse beef…The old whale approaches to black and is exceedingly coarse."[49]

In America, however, blackfish was more commonly eaten. On whaling vessels, blackfish were taken to obtain oil for lighting as well as a supply of fresh meat. The brains were a special delicacy when made into "dainty cakes," and the livers were prized as delicious.[50]

Some whalemen ate other parts of whales as well. "On the end of their noses [right whales] is a bunch of barnacles about 18 inches wide. This the whaleman called his bonnet…The barnacles are enormous as much as two inches deep—the boys roast them and eat them the same as oysters."[51]

Blackfish were also sought by whalemen for their oil. Blackfish arrived during the summer, rather than during the winter when other whales arrived. They were seldom seen earlier than June or later than December. Up through the nineteenth century, Cape

Codders used the terms blackfish and grampuses for what we today call pilot whales. They also sometimes called them "puffin pigs and cowfish." Some Cape Codders insist that puffin pigs were porpoises, not pilot whales.

In Greenland, pilot whales were also called "potheads." For the rest of this book, the animal will be called by whichever name the source uses—blackfish, pilot whale or grampus. These smaller whales swam together in large numbers and frequently beached themselves. Obtaining oil from pilot whales and using them as food continued into the twentieth century as frugal Cape Codders took advantage of any bounty given them.

In the head of the big fish is a quantity of very valuable oil. It is this oil that is used for lubricating oil for delicate machinery. This is sometimes called porpoise-jaw oil. The blubber is also boiled, but this product is used for tanning purposes and is by no means as valuable as the head oil.[52]

It is hard to describe the meat of the blackfish. "Blackfish meat is as good as porpoise—meat is coarser—sometimes made into sausage cakes and fried."[53] This description means little, as few have tasted porpoise. It was a dish for local fishermen, rather than the general population.

It was only a partially tongue in cheek response when a Cape Codder was asked in August of 2002 if he was going to visit the beached pilot whales in Dennis. "Naw," he replied. "My freezer's full!"

TECHNIQUES OF
HUNTING WHALES

Methods for hunting and trying the oil were not new to colonists. Contrary to what some believe, Indians did not do much true whaling prior to the arrival of Europeans. Elizabeth Little, one of the foremost researchers of Nantucket Indians and whaling, wrote, "In spite of tradition, I can find no evidence that Indians of New England routinely killed whales at sea, or used anything resembling a drogue, until the introduction of European whaling technology to the colonies."

The credit given by early whaling historians to the American Indians was apparently earned by their remarkable seamanship and innovative use of European technology.[54] "Successful colonial American whaling appears to have begun only after the American Indians learned an archaic European method of catching whales."[55] They were quick learners and played an extremely important role in colonial whaling, working alongside colonists.

It was obvious that Pilgrims didn't know how to hunt whales.

> *There was once one, when the sun shone warm, came and lay above water, as if she had been dead, for a good time while together within half a musket shot of the ship* [in Provincetown harbor], *at which time two were prepared to shoot, to see whether she would stir or no; he that gave fire first, his musket flew in pieces…But when the whale saw her time, she gave a snuff and away.*[56]

This account, written by one of the *Mayflower* passengers, pointed out their lack of knowledge.

We don't know who the first colonist was to kill a whale. Several writers attributed this to William Hamilton. According to the story, other colonists persecuted him for killing the whale, as they felt he was helped by evil spirits. Alexander Starbuck, the dean of early whaling writers, stated that it was an "unsatisfactory and improbable tradition… Hamilton is said to have removed to Rhode Island, and from thence to Connecticut where he died in 1746, aged 103 years."[57]

Postcard picture of sketch of whaleboat after whales.

Neither Hamilton nor any other variation of that name is identified by any genealogical source. There were whaling laws written by towns on Cape Cod as early as 1652 (Sandwich, November 7, 1652). Hamilton would have had to have killed his first whale before 1652, when he was less than nine years old.

A narrative written in 1612 described the English method of whaling. Samuel Purchase wrote in his *Pilgrimage*,

> *When they espy him on the top of the water (which he is forced to for to take breath), they row toward him in a shallop, in which the harpooner stands ready with both his hands to dart his harping iron, to which is fastened a line of such length that the whale (which suddenly feeling himself hurt, sinketh to the bottom) may carry it down with him, being before fitted that the shallop be not therewith endangered; coming up again, they strike him with lances made for that purpose, about twelve feet long, the iron eight thereof and the blade eighteen inches—the harping iron principally serving to fasten him to the shallop, and thus they hold him in such pursuit, till after streams of water, and next of blood, cast up into the air and whater (as if angry with both elements, which have brought thither such weak hands for his destruction), he at length yieldeth up his slain carcass as meed to the conquerors.*[58]

These methods were used by whale fishermen in America. It is interesting to note that there were other methods tried, including the use of nets made of strong rope.[59]

There is an actual record of finding and killing a whale on Cape Cod. A 1724 case resulted in affidavits being given by more than seventeen men. From these narratives, the following account was drawn.

A 1724 SHORE WHALING DESIGN

Shore whalemen from Barnstable, Yarmouth, Truro and Eastham, along with at least one Indian, had recently moved into whale houses in Truro for the start of the whaling season. The area was known as Hogback or Ryder's Cliff, a prime spot where whales came close to shore to feed.

On November 20, 1724, someone spotted two whales offshore. Seeing a mother whale with a yearling created great excitement, for whales had become scarce. At least seven whaleboats quickly left shore to pursue them. Twenty of the forty-two men in these boats were identified in the court documents. None of the boats had prior agreements to work together, a term called "mating." Bargaining between boats took place during the action, and was recorded in the documents.

The first boat to reach the whales was James Cohoon's (Cahoon), and they harpooned the yearling and were fast to it. Being fast meant the harpoon, called an iron by the participants, stuck in the whale. The iron was attached to a line, called a warp, and this was attached to their boat. The young whale spouted blood, a sign that the harpoon had hit a vital area. Whalemen called this area the "life" of the whale. It was a lucky toss, for harpoons didn't usually kill whales.

James Cohoon court affidavit. *Courtesy of John Braginton-Smith.*

Elisha Parker court affidavit. *Courtesy of John Braginton-Smith.*

Harpooning a young whale first was a common tactic, for men knew the mother whale, called a cow, would not leave her young. Two other boats came up to the whales, just as Cohoon, now confident he had killed one whale, turned his boat to harpoon the cow.

When Humphrey Purinton's boat arrived, he yelled over to Cohoon, asking if he needed help with the yearling. He was told no. Ebenezer Case's boat, now on the scene, was also told no help was needed. Case then attempted to harpoon the cow. Cohoon's harpooner, Eldred Atwood, was unable to get his second iron ready, and from that point on, Cohoon's crew worked only on the yearling.

Case, having trouble becoming "fast" to the cow whale, yelled to Purinton, offering him "half a quarter" (an amount of sixty-two pounds, as the whale's total value was later figured at five hundred pounds). Purinton's harpooner missed, just as Case's boat fouled them and removed them from any further action.

Ralph Smith's boat approached from the front of the whale, a somewhat dangerous maneuver, as the whale could easily upset the boat. Case yelled to Smith, making the same offer. Smith would have only one chance as the whale swam past them. Smith had faith in his harpooner, William Mark, who buried his iron in the whale's shoulder, and Smith's boat was fast to the whale.

During this time, Thomas Bacon's boat arrived and was now trying to harpoon the cow, as they saw no other boats fast to it. According to Ebenezer Case's later testimony, Case asked Bacon to help him. Bacon either didn't hear the request or ignored it because

Close-up of document by Jeremiah Bickford identifying area known as Hogback. *Courtesy of John Braginton-Smith.*

he felt no one was fast to the cow whale. John Lewis, Bacon's harpooner, struck the cow on the left side.

Near Bacon's boat was still another boat, John Knoll's. Seeing Bacon fast to the whale, Knoll's harpooner, a man named Vickeries (Vickery), put down his iron and picked up the lance, the next step in the killing process. They thought they succeeded, even though the whale eventually dragged them half a mile.

Jeremiah Bickford's boat arrived shortly thereafter, joining the chaotic scene. Since Case wouldn't call them in, they attempted to harpoon the cow on their own, but failed.

Portion of testimony by John Knoll identifying whale as a "brod back" [broadback, or right whale]. *Courtesy of John Braginton-Smith.*

Sustaining several harpoon wounds as well as lancings, the cow whale soon died. Unfortunately for all, she sank shortly after dying. This was something that didn't usually happen with right whales. John Knoll called her a "brod back whale." The term "brod back" has not been seen in other writings. The dam may have been a "dry skin" and this was the reason she sank. There is no evidence that the baby sank.

The iron from Smith's boat came loose when the whale sank, but it was all twisted and bent, showing that at one point it had been fast to the whale. When the dead cow whale finally came onshore a few days later, it was found on its left side, partially buried in the sand.

Testimony indicated that the whale had been struck at least five times by harpoons. John Snow Jr., one of the first on shore to see the whale, saw an iron marked with a "P.W." in it. Some said that this was Ebenezer Case's iron. Others onshore related seeing Thomas Bacon and John Lewis's irons with the whale, as well as the lance wounds by Vickeries.

The boats made claims as to where their harpooners had struck the whale: Vickeries's (Knoll's boat)—right side of bulge; John Lewis's iron (Bacon's boat)—left side, low down and right side of whale in her "smale"; Ebenezer Case's iron (Case's boat)—in the shoulder; and William Mark's iron (Smith's boat)—left side near the shoulder blade, pointing backward.

Apparently, Case and his crew "by force on arms" did take away the "blouber and whale bon." The complainants, Thomas Bacon and Ebenezer Lewis, stated this, and asked the Barnstable sheriff to "attach the goods of Ebenezer Case and Jacob Pol [Paul], Indian, both of Barnstable, to the value of 500 pounds."

Only Thomas Bacon's boat was involved in the suit. Case must have settled with Ralph Smith and John Knoll. It was smart for Case to settle with Smith, for that family had a reputation for being extremely tough and wily. An affidavit by Benjamin Cullings stated that Ebenezer Case offered whalebone (baleen) as well as oil to Thomas Bacon after it had been tried out. Thomas Bacon refused, feeling the whole whale belonged to him.

This case was tried in Barnstable court in January 1725 (old style 1724/25). In addition to the sheriff's document, there were at least seventeen documents of testimony. We know this as several documents were numbered, with the highest number being

John Hallet court affidavit. *Courtesy of John Braginton-Smith.*

Benjamin Cullings court affidavit. *Courtesy of John Braginton-Smith.*

seventeen. Of those, fourteen still exist. Unfortunately, the words of the plaintiff, Thomas Bacon, and the defendant, Ebenezer Case, are missing. They had to appear in court and no written testimony was taken. Most of the other men submitted written testimony rather than taking time for the long journey to the Barnstable Courthouse during the whaling season. Smith lived up to his family's reputation, feigning illness to prevent the trip, and this allowed him to continue looking for whales off Hogback.

Nathaniel Otis, clerk of the court, was the brother of James Otis of Barnstable, the man directly involved with the whaleboat purchases during the French and Indian War. Mercy Otis Warren of Revolutionary War fame also was from this family.

The results of the case will never be known, as the Barnstable Courthouse burned a century later, destroying all records. The affidavits were collected by John Braginton-Smith over a number of years and he reunited them for the first time since the actual court case in 1725. Some of these documents are illustrations in this book.

WHALING GROUNDS AND HOUSES

During winter months, whale fishermen lived in areas where whales were frequently seen. These included the lands around Cape Cod Bay and the southern shores of Nantucket and Martha's Vineyard.

Samuel Dyer court affidavit. *Courtesy of John Braginton-Smith.*

Whaling houses were occupied from November to mid-March. A lookout was posted at a high point on dunes or a hill, or up a tower. The tower was often nothing more than a post with a platform on top of it.

One of the shore whale fishermen's western locations on Cape Cod Bay was Sandy Neck in Barnstable. The Reverend John Mellen noted, "This business [in Barnstable] employed nearly two hundred men for three months of the year."[60]

In 1715, the proprietors of Barnstable divided the Sandy Neck lands. "Reserving Priviledg & use of four spots or pesses for the setting up of four try houses of about half an acre to each for ye laying blubber barrels, wood, & other nessesceries for ye trying of oyl as need may require."[61] Four places on the Neck were reserved as try yards, one of them about a quarter of a mile west of Braley's. (Brayley's is a sand dune named for Braley Jenkins, a cranberry grower, lying north of Big Thacher Island.)[62]

Housing for the whale fishermen was on the north side of the neck, known to locals today as the backside, so observers could watch for whales. The backside was earlier known as the North Shoare and the marsh side the South Shoare. Try yards were on the marsh side of the neck. Horses pulled carts containing pieces of blubber cut from the whale across the sand to the south side dunes near the marshes where the try pots were located. Bricks and charcoal still remain in these locations. A few wharf pilings are still visible on the marsh side where barrels were loaded onto vessels.[63]

"Whale houses were permanent structures, with cellars in which New England rum doubtless was stored against the cold and long evenings. They contained bunks to sleep in."[64] There must have been a substantial number of houses, as it is reported that upward of two hundred men stayed on Sandy Neck in the winter. Since there were sixty separate lots in the 1715 division of Sandy Neck, it is logical that there were whale houses on most of them.

In Yarmouth, whaling grounds also were laid out. While the date when this occurred isn't known, the proprietors enlarged the reservation in 1713 by adding about two acres at the west end,[65] where fresh water could be found. The proprietors identified the land as "that a piece of land and beach lying near ye Coy Pond belonging to ye proprietor in Yarmouth: containing about 2 acres be it more or less: shall forever ly undivided for ye benefit of ye whale men of this town of Yarmouth." This area was known as Black Earth and today lies within the bounds of the town of Dennis.

A letter written to the *Yarmouth Register* by Thomas P. Howes in 1860 further described the whale houses at Black Earth:

> *They were buildings of considerable extent, with cellars under them, where doubtless was stored the means for "mixing a mug of flip." The whale house contained two apartments, with sleeping bunks for the accommodation of those who came from a distance. For many of the boats' crews came from Harwich (now Brewster) and the south side of Yarmouth. It is said that thirty-six boats have been engaged in one winter, in whaling in Dennis…[One] house was built by Lieutenant Jonathan Howes, who employed, or owned, a crew of Indians.*
>
> *TPH*[66]

The location of one whale house was where the pavilion of the Nobscusset House stood.[67] Another whale house had been built just west of Sesuet Harbor.[68] With thirty-six boats at Black Earth, it is probable that there was a whale house for each of these crews to live in, which means that more than two hundred men were living there.

No town records indicate locations of whale houses in Brewster, but the 1880 *Barnstable County Atlas* identifies fish houses at Crosby Hill. The 1907 *Atlas of Boundaries of Town* shows an oil house just south of the boundary between Wellfleet and Eastham on Billingsgate Island, about 150 feet northeast of the lighthouse.

On Great Island and Lieutenant's Island in Wellfleet, whale houses were built and used by both colonists and Indians.[69] A tavern on Great Island was built sometime in the late 1680s or '90s. A cooperative archaeological dig by the National Park Service and Plimoth Plantation in 1969 and 1970 studied this tavern in detail. James Deetz, archaeologist for Plimoth Plantation, wrote, "It is highly probable that the building was two full stories in height with the upstairs rooms serving as sleeping quarters for what would prove to have been shore whale fishermen who used the building, which provided them with immediate access to the beach. By seventeenth-century standards, rooms of this size could accommodate as many as ten people each."

In addition, a large whale vertebra was recovered during the dig that had been used as a chopping block, as well the foreshaft of a small harpoon or lance. What may be the earliest piece of scrimshaw in New England was discovered in a refuse heap just south of the tavern's foundation. It is a carving of a man's head wearing a cap.[70]

Perhaps the tavern had a more nefarious past. "With their wives and children just a few miles away, Nantucket's alongshore whalemen may have been relatively well behaved, particularly compared to those at more isolated whale stations on Cape Cod where archaeological digs at Great Island have revealed evidence of a veritable den of iniquity, complete with a tavern and perhaps a brothel."[71]

Some called it Smith's Tavern, named for the Smiths of the area who were well known as whale fishermen.

> *Regarding Smith Tavern, local lore has it that there was a sign which said,*
> *"Samuel Smith, he has good flip,*
> *Good toddy if you please,*
> *The way is near and very clear,*
> *T'is just beyond the trees."*[72]

Judging from documents written at this time, a number of whale fishermen were illiterate, and one wonders why a sign would have been made. It's a good story, but with little substantiation.

The division of common land at Great Island and Lieutenant's Island resulted in moving the whale houses to Billingsgate Point. No wood was available there, but there were probably more whales.[73] By 1738, the Eastham town meeting complained "the only place [this] ancient town hath to sit down for whaling is Billingsgate Beach Point, where the whale houses now stand."

Truro had formerly been part of Eastham, separating in 1705 and incorporating in 1709. Whale houses and lookouts lasted into the 1750s in this area. Around the middle of the century (1750), Mr. Richard Paine told Shebnah Rich that he could remember when there were lookouts stationed at Pond Landing [Truro] to watch for whales. As soon as a whale hove in sight, the lookout would cry out "Towner," an Indian word that originally signified that the lookout had seen the whale twice. It was recorded in Truro that a lookout's shout in the excitement of the discovery was actually heard two miles away![74]

Author Shebnah Rich identified specific whaling locations in Truro. "Many of the names had an oily flavor when the Eastham settlers first came to Paomet[Pamet], as Try House Lot, Whale House Hill, etc. The last was the high bank near the South Truro Landing, where were kept the boats and try works and lookouts for the south part of town."[75] He further related that old-timers could remember when there were lookouts at Pond Landing.

Nantucket's whale houses were along the island's south shore. While Michel Crèvecoeur stated that there were four whaling stations on Nantucket, some Nantucket writers don't completely agree with this. Elizabeth Little explained the issue: "I propose that Crevecoeur's description applies to the earliest whaling, 1690–1695, and that a later growth in the number of whale houses took place at the most profitable sites, Hummock Pond and Weweder, resulting in the configuration which Macy recalled."[76] Some houses that were reputed to have been whaling houses still remain on Nantucket.

Zaccheus Macy recalled, "The Hummock Pond, whare we once had a great number of whale houses with a Mast raised for a Look-oute, with holes bord through and sticks put in like a Lader [ladder], to go up." The specific locations of these masts were identified. "Near the center of each division, or about three and one half miles apart, was erected a mast provided with cleats, which was used for the purpose of a lookout."[77]

Whale watcher houses in other colonies differed from those on Cape Cod. Some on Long Island were identified as wigwams.[78] In warmer land to the south, North Carolina made some use of "whale fishers" tents.[79]

WHALEBOATS

A vessel was needed to carry whale fishermen to whales, and to tow killed whales back to shore. Indians' dugout canoes were unwieldy and not very stable in waves. Since whaling was done between November and March, vessels had to carry a crew of six and remain stable and maneuverable in very cold, choppy waters.

These vessels evolved through trial and error. Perhaps it was refinements of these early boats, made in the American colonies, that caused Nantucket and then Barnstable to try to lure Jacobus (James) Loper from Long Island to teach his knowledge. Loper declined Nantucket's invitation, but did travel to Barnstable about 1680.[80]

There are some references about exact locations where whaleboats were built. "Across the road from the East Sandwich depot is the house that Barnabas Holway, expert boat builder put up in 1720…And its long low shed in the yard where Barnabas and his

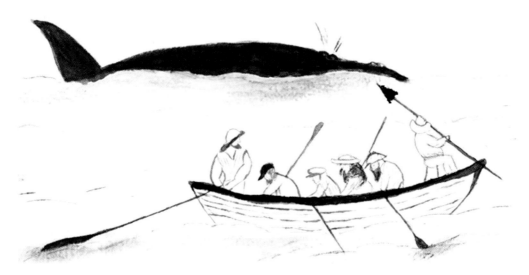

Sketch of whaleboat after a right whale. *Courtesy of the artist, Lee Lombard.*

family built whaleboats."[81] Another reference cited Deacon John Paine of Eastham as another of many builders of whaleboats.[82]

"The whaleboats of this period were commonly constructed of cedar clapboards and were pointed at the stern as well as the bow. This design, similar to that of a modern canoe, enabled the vessels to be paddled both forward and back."[83]

Regrettably, no pictures of early whaleboats exist. Two silhouette drawings exist, one showing small whaleboats on a "Mape of Ye English Empire in Ye Continent of America" about 1700, and the other appearing on a 1733 map of North Carolina by Edward Moseley. Unfortunately, few details can be seen.

A North Carolina article included a picture of a nineteenth-century North Carolina resident with a whaleboat he was building.[84] The caption beneath the picture stated that the basic design dated back to the fourteenth-century Basques.

Only one source gave actual dimensions of an eighteenth-century whaleboat. Undated notes found and identified by Elizabeth Little may represent the dimensions of a 1710 Nantucket whaleboat. These notations were on the opening page of an account book kept by Richard Macy of Nantucket.

Little states that the boat's cedar planking was lapstraked, or overlapped. Other accounts confirm that whaleboats were double-ended from at least 1696 on. She suggests the several lengths of oars are additional evidence for a tapered stern. The shape of a whaleboat determined a variety of oar lengths, depending upon the position of the oarsmen.[85] In her research, Little found oar lengths varying from 12½ feet to 16 feet, and one steering oar of 17 feet, as well as evidence that it took two men about three days to build a whaleboat.

Some researchers have mentioned that whaleboats were powered by spiritsails.[86] However, none of the whaleboats listed in wills specifically mention spiritsails. The term

"craft" was used during shore whaling days as a term to cover all equipment used in a whaleboat.

There is another source for information. Paul Dudley of Boston wrote in 1725,

> *I would take notice of the Boats oure Whalemen use in going from the Shoar after the Whale. They are made of Cedar Clapboards, and so very light, that two Men can conveniently carry them, and yet they are twenty Feet long, and carry six Men, viz. the Harponeer in the Fore-part of the Boat, four Oar-men, and the Steersman. These boats run very swift, and by reason of their lightness can be brought on and off, and so kept out of Danger.*[87]

Dudley's comment that the whaleboats were twenty feet long is different from a report nearly fifteen years earlier. A 1709 planned invasion of the French Maritime Provinces stated,

> *Col. Church, who being bred up amongst those Indians demonstrated to us the vast use those whale boats could be of in the great River of Canada, being farr nimbler than any pinace, able to carry 15 men each being about 36 foot long, yet so light that two men can easily carry one of them, those wee found would be of so great use in surprising of places or vessels in the night.*[88]

Colonel Benjamin Church was a well-known soldier from King Philip's War. Church planned and participated in invasions of Canada for several years. He tried to recruit Cape Cod whale fishermen to man boats for the 1704 invasion. It wasn't the first time these men had been sought, and many didn't want to go.

Ten years earlier, Captain John Thacher wrote to Governor William Stoughton: "All our young and strong men are employed in whaling and mostly have their rendivous remote from the towns and if they see any man coming towards them, presently mistrust; make a shoute and run into the thickets."[89] Men didn't want to be "impressed," meaning they would be taken into military service against their will.

Colonel Church was able to get whale fishermen to help him. "In May, 1704, Col. Benjamin Church sailed with 550 men, 14 transports, 36 whaleboats, and 3 ships of war against Arcadia…Probably many from Monomoit [Chatham] went with him, as Col. Church visited every town on the Cape the winter before, seeking recruits for the whaleboat fleet."[90] Church visited the Cape in winter because that's when the whaleboats were manned.

The Cape furnished whaleboats and men for at least five expeditions to Canada during wars with France. There are many records of whaleboats being procured on Cape Cod for use in these expeditions.

On June 29, 1722, there was a resolve for ten whaleboats.[91] Later the same year, Israel Tupper was sent to Sandwich and other parts of the Cape to find twenty "good and sufficient" whaleboats for the service of the Province.[92] The sum of fifty pounds was paid "to Capt. Thomas West Brook on account of Five Whale Boats & two canoes delivered

for use by the province."[93] These were delivered at the height of the whaling season, which perhaps explains the high price. In January 1723, Joseph Bacon was paid four pounds for bringing a number of whaleboats from Cape Cod to Boston.[94]

Two whaleboats from the garrison on St. George's River were involved in an Indian skirmish on April 30, 1724. St. George's River is between Rockland and Pemaquid Point on the Maine coast. Seventeen men were carried in the two whaleboats, which were attacked by thirty Indian canoes. Only three men escaped death.[95] Edmund Mountforth was paid in June of 1724 for repairing whaleboats and other things[96]; he was later was paid for making oars[97] and for repairing whaleboats and making coffins.[98] It is reasonable to assume that the coffins were for the fourteen men who were killed by Indians on St. George's River.

In spite of the value of these versatile boats, the men who manned them were not held in high esteem by soldiers. This was lamented by John Gorham of Barnstable, a whale fisherman as well as an officer in the militia. Writing in his *Wast Book*, he lamented, "If these men had been Called footed men in Stead of whale men, We should souvive mutch better. They had the same opinion of Whalemen as I had of Neagr Head—when children hard headed Knocked head with a hamer."[99]

Gorham even wrote a poem reflecting on the poor lot of the whalemen.

> *But serving Envy, like the Sun does beat*
> *With Scorching Rays on all that's brave V Greater*
> *The ill-Requited Whalemen in the Bough*
> *The misfer send to shade thy Standring Brow*
> *Lampooners like Squibs may make a present blaze*
> *But time and truth pay Respect to Rays.*[100]

Gorham noted the dangers for soldiers riding in whaleboats. "Me thinks I shall always hear of dolfull drowning notes to Neptune Who now kills more than Bullets in ye Boats. It is not Iron and Lead that did from Cannon Rore so much as ticklish boats."[101] His final comment about whaleboats gave the men manning them a kind of immortality: "And Whalemen So Killed Rise—Conquer on again."[102] While it appears that Gorham wrote his book to be read by others, spelling and punctuation make reading it a challenge! However, his feelings show through very clearly.

Another Barnstable man procured whaleboats for the French and Indian War. After first supplying Thomas Hancock with four whaleboats in 1755, James Otis began collecting and gathering available whaleboats in the area. He directed his son Joseph to go and buy all available whaleboats. "Make no noise and Dont tell any Body what you are about."[103] Otis was able to purchase thirteen thousand feet[104] of timber at that time, so it appears he was building whaleboats as well, but there are no records to show where the wood came from or where the boats were built.

In 1757, Otis purchased seventy-eight boats for £380. Including the cost of carting, transport, freight and delivery to New York, the bill came to £772. Otis added a 5 percent commission of £38.[105] In August of that year, Otis was asked by Governor

Thomas Pownall of Massachusetts to forward to New York another one hundred whaleboats, and the next year General James Abercromby placed an order with him for two hundred more.[106] Otis was accused of inflating freight charges and one man, Ebenezer Chipman, called him "an old Pirate and a Cursed old Rogue."[107] The feeling that James Otis was cheating the government put an end to his efforts.

What made these whaleboats so desired by the army? Although these boats did not receive the honors they deserved, enough people in the military knew of their potential. These light, lapstrake boats of cedar were very fast.[108] Nantucket residents realized the importance of maintaining resources of cedar as early as 1694. In that year, they made it a crime to use cedar trees for any purpose other than "whale bots or the like."[109]

Whaleboats usually carried a six-man crew; the mate (who usually steered), the harpooner and four men to row. In some boats, the harpooner and mate changed places after harpooning. It was the mate's job to use a lance to kill the whale.

Indians and whites intermixed in crews. In at least one known case, an Indian was in charge of a crew. A black slave also led a boat. Crews often operated together in groups, with one person in charge of several boats. These boats were said to be "mated" and the word "mat" is seen in documents.

CLOTHING AND EQUIPMENT

Since whaling crews operated during the coldest months of the year in open boats, they must have dressed very warmly. No records exist describing the clothes worn by whale fishermen. It is known that long shirts or old gowns were tied between the legs and often served as underclothes. Master Graves of the *Mayflower* owned a suit of canvas clothes.[110] This suit was worn over a linsey-woolsey jacket and pants. Canvas was one of the less expensive cloths, so it is probable that seafaring men used it. Some seafarers had wool frocks for outer coats, wool being a particularly useful material as it retained its insulating characteristics even when wet.

Fabric could be made more waterproof. One way was to use oiled linen.[111] Beeswax helped waterproof outer garments. Lanolin from sheep wool helped waterproof shoes, which were sometimes called brogs. Stockings were made from thick, coarse wool. Hats, later called Monmouth caps, were wool caps or old wool socks. Heavy woolen mittens were worn. They were not windproof, and were sometimes soaked in salt water and then wrung out to make them windproof. Hands were warm, but wet.[112] Even with this clothing, whaling was a very cold business and those employed in this business just had to tough it out!

In the whaleboat, in addition to the four oars and steering oar, were usually two harping irons (harpoons) as well as lances and rope (called warp). Each boat normally carried a hatchet to cut the line should something go seriously wrong.[113] These items together were known as "craft." When Samuel Smith died in 1697, an inventory of his estate listed "whaleboats and craft belonging to them" valued at twenty-six pounds and eight pence.[114]

The harping iron had a two-flued head. The head remained virtually unchanged in the American whale fishing industry until midway into the nineteenth century. Sometimes whale fishermen attached "drug," or drogues, to the line. This was a float that dragged along the surface, tiring the whale and helping men keep track of the whale's location when it submerged. Basque whale fishermen had used drogues as early as the thirteenth century.

Sometimes they attached the harpoon line to the vessel itself, and were dragged by the whale. A good example was described on January 1724, when John Knoll testified, "[said] whale did two [tow] us about half amile and was almost always above water."[115] Being dragged by a whale was known as being fast to a whale.[116]

It was incredibly dangerous and difficult to get close to a whale. The *Boston News-Letter* on December 8, 1712, reported that six men in a whaleboat off Gurnet Beach near "Duxberry" were overset and all drowned.

The harping iron was tossed when within fifteen feet of the whale, but it was not designed to kill the whale. It was designed to get the whaleboat attached to the whale by a line (warp) so that lances could be used to pierce the tough skin and strike vital organs, thereby killing the whale.

The harpooner often changed places with the man in the stern (sometimes called a boat steerer or boatheader), who was the mate. The mate was responsible for killing the whale and the harpooner at that point became the steersman. The mate tried to strike the lance into the "life" area of the whale, where large arteries held oxygenated blood used for their long dives.

Whale fishermen had to remember where they had struck the whale, for often they lost direct contact with it after it had been harpooned and lanced. Harping irons had initials marked on them so that they could be identified by their owners.

While right whales usually floated when they died, finbacks and humpbacks sank. Court cases frequently had to determine the ownership of a dead whale that might have beached days after the hunt took place.

TRY YARDS—PROCESSING THE WHALE

After the whale had been towed ashore, the blubber and baleen were removed.

> *The first operation, taking place on the beach at low tide, was to cut off the lips. Then the valuable bone was removed from the head; finally the head was cut off. Next we cut and peeled off the body large blanket pieces of blubber on the topside; leaving a slab up and over the outside, to which we could attach a hawser and tackle. With these we could roll the whale over at the next high tide. The carcass was rolled on each tide until the blubber had been stripped off. This took two or three days.*[117]

A crab, an instrument similar to a capstan, was used to heave and pull the blubber off as fast as it was cut. The blubber was then put into carts and carried to try yards, which

were often near to their dwelling houses.[118] The lips, interestingly, were composed almost entirely of blubber and could yield large amounts of oil. The tongue afforded less oil than any other blubber. The bones of the whale were very porous and contained large quantities of fine oil. Four tons of blubber afforded three tons of oil.[119]

Blubber was hauled to try pots in wagons, while workers attempted to keep from getting any sand on it. Try pots weren't terribly expensive. Samuel Smith's estate in Eastham in 1697 lists "four try pott and one canoo & shoop (?) and grindston" worth five pounds and five shillings.[120] How big were try pots? In North Carolina, they were about fifty gallons capacity.[121]

> *Arriving at the try-house, the whale's flukes were hauled in first; then the strips of blubber, cut six feet long, two feet wide, and six inches thick, were laid on the flukes so that the whalespade might not be dulled by hitting the dirt. This whalespade was then used to cut horse-pieces (two feet long, three inches wide)…The horse-pieces would be cut with a mincing knife, cutting slabs one-fourth inch thick, leaving a corner attached so that when they were pitchforked into the kettle a quantity could be put in at once.*[122]

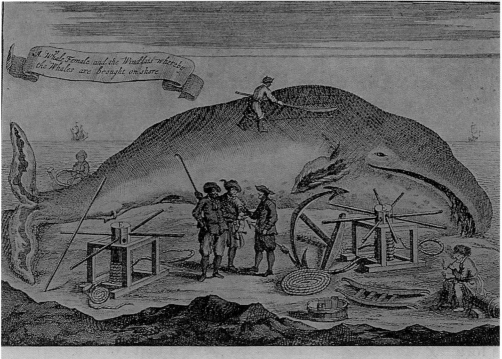

Early method of bringing whales on shore by means of a windlass.

Using a windlass, from *Whale Fishery of New England*, by State Street Trust Co., 1915.

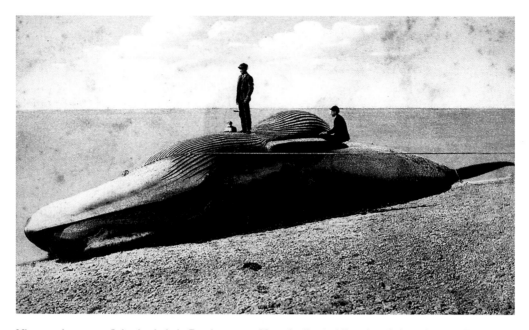

Nineteenth-century finback whale in Provincetown. Note the line holding the whale so it won't float out at high tide. *Postcard courtesy of Ed Zabloski.*

Coopers were vital to this operation, for whale oil had to be put in barrels. When Plymouth became part of Massachusetts Bay Colony, almost immediately a law was passed regarding this issue: "That is to say, butts to contain one hundred and twenty-six gallons; puncheons, eighty-four gallons; hogsheads, sixty-three gallons; tearses, forty-two gallons; barrels, thirty-one gallons and a half; and made of sound, well-seasoned timber, and free of sap…and every cooper shall set his distinct brand-mark on his own cask."[123]

Interestingly, the buttery room of a Cape house was not where butter was stored; rather, it was where these large barrels were stored, thus giving rise to the word buttery.

Wood was used to start the fires to boil the blubber, but "after a copper [pot] or two had been boiled, the finks or fritters were always sufficient to boil the remainder without any other fuel."[124] The smell of cooking blubber was distasteful, and the smell of dead whales could be nauseating. Rendering blubber took up to a week, depending upon the size of the whale, with fires burning day and night.

Whale oil could not be put into wooden casks until it had cooled sufficiently to allow one to touch it without feeling real heat. If oil was placed in wooden barrels while still hot, the barrels leaked when the oil cooled as the wood shrank.

Workers had to be fed during the round-the-clock trying out process. There are notations that food such as chicken was dropped in the hot oil and deep fried, as was dough (to be made into doughnuts).

Two articles written in the 1980s describe trying out whale oil. The authors wrote of cooking doughnuts in the oil, but no one tried to eat them because the whale had been

euthanized with drugs.[125] These same articles describe the smell associated with the process that resulted partly from using blubber for fuel, after it had lost its oil. It smelled like burning flesh when thrown in the fire.

Trying oil was dangerous. On July 23, 1741, the *Boston News-Letter* reported that an old man, Nath Harding of Truro, was watching the work of boiling the oil when he fainted, fell into a try pot and was severely scalded. The newspaper stated this happened on July 14, which suggests that it was oil being taken from pilot whales, as they frequented the Cape Cod coast in summer.

The actual locations of some of these try yards can be found in records. On Sandy Neck in Barnstable, four areas were set aside for try yards. These try yards were on the inside or marsh side of the neck, and they were discovered by the presence of charcoal and broken bricks, which are still in evidence. One of the lots is called Try Yard Meadow. The remains of pilings can be seen in the mudflats. These seem to be remains of docks where oil was transferred to small vessels.[126] A thirty-foot-wide man-made ditch goes up into the marsh.

Yarmouth had try works at Black Earth. Captain Ebenezer Howes's (1637–1726) will mentions his try works. Ebenezer's will reflected his wish that his whale house and try works be sold and the money that they brought be divided among his nine daughters.[127] There was at least one try work on the Nantucket Sound side of Yarmouth as well.

The Wildlife Sanctuary run by the Audubon Society in Wellfleet includes Try Island, which was almost certainly the location of a try yard. A 1715 Eastham document allowed try yards to be set up by inhabitants wherever whaleboats came ashore.

The try yard at South Truro landing ceased to exist by the mid-1700s, as a 1749 report states: "April 17 gave leave to Barnabas Paine and Job Avery to open the hedge by the old Try Yard on the southerly part of the Indian Neck."[128]

Provincetown had try yards, but only those from the nineteenth century are documented. On Nantucket, they were on the beach along the south of the island,[129] and Martha's Vineyard had at least two try yards. One try yard was owned by John Butler at Edgartown.[130] "Another was at Holmes Hole. The Butler try house was in use before 1748; the Holmes Hole was 'quite early.'"[131] In 1738, Captain William Chase, a Nantucket whale fisherman, moved to Edgartown and bought twenty acres of land by the harbor. He set up try works and a wharf. He failed due to insufficient business. Three others also tried to do the same and failed for the same reason.[132]

WAGES

Unlike European whale fishermen, who received fixed wages, compensation for Americans depended upon success.

> *The method of compensation was to give each member of the crew an agreed upon share of the oil or bone of each voyage, or to credit the oil and bone to a whaleman's account…In return for the investment in tools, and frequent replacement and repair costs,*

the owner of the boat and craft received a half share in the proceeds of each voyage. The crew, including the captain, divided the other half...division of the crew's share into eighths, with the harpooner and captain receiving double shares.[133]

Unless indentured, Indians usually received the same wages. The earnings of the indentured man belonged to the person holding the indenture, who was called the master.

Harper's Young People magazine cover of 1885. Many methods shown were used by early Cape Cod whale men, but harpoons are far more advanced.

A Chronological Look at Shore Whaling

When drift whales washed up onshore, landowners felt they owned them. Many land-court cases attest to the inhabitants' strong desire to retain total control of land they owned. Surprisingly, Plymouth did little to control this potential windfall until the 1650s.

From its founding in 1630, Massachusetts Bay Colony's men were aware that there were whales for the taking along the shores of Cape Cod. Most drift whales ended up on beaches there, rather than farther north along Massachusetts Bay. It doesn't appear that Plymouth Colony objected to outsiders coming to their colony to take whales.

Early Massachusetts Bay Colony regulations regarding whaling were general in nature. In 1639, "For further incuragement of men to set upon fishinge, it is ordered, that such ships, & vessels, & other stock, as shalbee properly imployed & adventured in takeing, making, & transporting of fish, according to the course of fishing voyages & the fish it selfe, shalbee exempt for 7 yeares from henceforth from all countrey charges."[134]

The first vessels were not traditional whaling vessels. They were used to carry men to look for drift whales and bring back the oil. During the 1640s, both colonies realized the importance of creating legal incentives to help the maritime industries. Thus were born laws that gave Massachusetts residents the right to own land to the low tide level. These laws were written to encourage individuals to place wharves and piers on their own property. Today, these same laws effectively limit public access to many of Massachusetts's beaches. Right of trespass was allowed only for fishing, fowling or navigation.

In 1641, Massachusetts Bay became directly involved in harvesting of drift whales. The General Court ordered and decreed, "Also any Whale, or such like great fish cast upon any shore, shall be safely kept or improved where it cannot be kept, by the town or other proprietor of the land, til the Generall Court shall set order for the same."[135]

It was 13 years before laws further regulated ownership. Regarding a whale taken at Weymouth, a court order on May 14, 1654, declared, "The countrje shall have one third pte, the town of Weymouth another third pte, and the finder the other third pte."[136]

In spite of Plymouth Colony's sizeable debt to founders who remained in London, it was slow to try to control whaling for its economic advantage. Beaver and otter furs

were lucrative trade items, and the Aputucxet Trading Post brought in needed revenue. It wasn't until 1652 that Plymouth Colony started to exert control over the whaling industry. At the same time, Plymouth courts tried to control the complaints arising from conflicting claims for whales.

The earliest drift whaling legislation by the Plymouth Colony took place on June 24, 1652.[137] "This Court now ordereth that of every whale either cast on shore or brought of any Indian or Indians or taken on drift att Sea and brought to shore in any pte of this Jurisdiction there bee one barrell of merchantable Oyle paied to the publicke Treasury."[138]

The ethics of religious life didn't always extend to economic life, especially when paying taxes with oil. Some towns were sending damaged barrels or ones not quite full, as a General Court ruling was needed to shut one loophole. On July 4, 1656, "The Court has ordered…all oyle shal bee delivered att Boston viz a full barrel of merchantable oyle."[139] The word "merchantable" meant that oil had to be unadulterated and the full barrel could be sold. This ruling did not resolve all problems, as the town of Yarmouth was accused in 1660 of not filling barrels.[140]

The treasurer's account for the colony always was the final say, even when there were problems. A notation on this account on June 10, 1658, stated, "By mistake in one barell of oyle less 02:00:00 this is a trew account, errors excepted."[141] How the treasurer could manage a "trew account" with errors shows creative financing isn't limited to modern times, but stretches far back in our history.

Plymouth knew the importance of coopers and the making of casks. "That all such Caske as are made by any Cooper within this Government shall have the two first letters of his name sett upon such Caske hee makes by a burnt mark…That all Coopers within this Government are to make all their Caske according to London Gage upon the like penaltie."[142]

This new law allowed Plymouth to place blame for leaking or undersized barrels. Individual towns selected whaling agents to ensure the oil was delivered to the colony. This same law also assigned ownership. "At its core, the law assigned beached whales and drift whales within a harbor or one mile from shore to the town where they were found. Beyond those limits, whales belonged to whomever brought them in."[143]

The term "to whomever brought them in" indicates men were shore whaling from boats and were traveling more than a mile from land. Competition and ownership became contentious issues. Whaling had progressed a great deal from the early attempts to merely take oil from dead whales on the beach.

Individual landowners felt this law was unfair, for the town assumed ownership of any whale that washed up on private land. It didn't take long for a challenge. A 1654 Court Order regarding title to whales cast up on private lands tried to resolve this.

The Court have ordered and granted, that whatsoever whales or blubber shall be cast up against the lands of the purchasers, that the proprietie thereof shal belonge unto the said purchasers accordingly as unto any of the particular townships when such whales or blubber sails within any of the paticulare townships when such whales or blubber fales [falls] within any of theire precincts.[144]

The first document from a Cape Cod town that mentions whaling appeared in Sandwich in 1652, less than a year after selectmen were first permitted. Barnstable has no records at all regarding early whaling. The reason? Barnstable voted at a town meeting on October 16, 1649, "Ordered by ye Inhabitants that Henry Cob Isaac Robinson Thomas Lothrop & Thomas Hinchley do peruse ye old Town Book & Record such material useful Orders as they find therein this Town Book and ye rest in ye Old Book to be canselled by them."[145] Almost everything but land ownership was cleansed from the records.

All of Yarmouth's early records burned in a 1675 fire at the house of Edmund Hawes, town clerk at the time. Eastham has few records prior to 1660.

Sandwich established a process to handle drift whales on November 7, 1652. It is probable that the other three towns also passed similar laws.

> It is ordered that Edmund Freeman, Edward Perry, George Allen, Daniel Wing, John Ellis, and Thomas Tobey…are appointed to take care of all the fish [whales] that Indians shall cut up within the limits of the town, as to provide casks for it, and to dispose of it for the town's use. It is likewise ordered that if any man that is an inhabitant finds a whale and gives notice to any of these men aforesaid, he shall have a double share. It is further ordered that these six men shall take care to provide laborers and casks and what other things are needful for the best advantage, that so what whales either Indians or English give them of, they may dispose of it for the town's use to be divided by them equally to every inhabitant.[146]

Four of the six men were either Quakers or sympathizers. There was dissatisfaction with the method, for three months later, on January 24, 1652/53, the town meeting ordered that "the pay of all the whales shall be divided to every householder and to every young man that has his own disposing equally."[147] Things still did not work smoothly, and by the next whaling season Sandwich changed again.

> 1653 December 13. It is ordered that Richard Chadwell, Thomas Dexter, John Ellis… are to have all the whale that comes up within the limits and bounds of Sandwich, and for the said whales they are to pay to the town Sixteen Pounds apiece for each whale—Provided any of them have notice given them by any man that has seen the whale ashore or aground, and returns to the whale staying one hour by the whale, and his own oath is to be taken for the truth and certainty of the thing, to make these three persons above mentioned liable to pay for the said whale in case one of them does not go along with him that brings them word that there is a whale cast up—but if any of them returns with him that gives them notice, then the person that gives them notice, he shall help to seize the whale, and the person whoever he be that will do accordingly as is herein propounded to give notice in the towns behalf to any of these men he shall have paid him for his pains and care herein Twenty shillings.
>
> If in case there comes up a piece of a whale, that is to say, a half or quarter part or three parts of a whale, it is so appointed that these four men, Mr. Dillingham, Edmond Freeman, Edward Perry, Michael Blackwell are chosen to see the part of the whale before it be cut any of from it, and to determine what quantity there wants of a whole whale without a tongue—furthermore Richard Chadwell, Thomas Dexter, John Ellis are to

make payments for all the whales, thus, a third in Oil, a third in corn, a third in Cattle all merchantable payment, at a current price, likewise for what pay is made in cattle the town is to make choice of one, and these three men another to determine the price, and if these two men cannot agree they are to choose a third man.

It is agreed that the town is to pay the barrel of oil to the country, and the twenty shillings of the man that gives notice of a whale—If any of these men find a whale themselves without notice given them, they are to have in like manner twenty shillings, and this agreement to be in force until this day, twelve months.

Witness our hands
Richard Chadwell
John Ellis (X) his mark
Thomas Dexter[148]

The complexity of the above document makes it clear that whaling was not a new venture. Choosing John Ellis to be accountable for town oil was an interesting choice, as he probably was illiterate, having signed the 1653 agreement with an "X." Over the next several years, the business of handling and distributing whale oil played a prominent role in Sandwich records. Indians were paid separately from other townspeople.

The town jealously guarded its stock of oil, not allowing people who moved away to receive a share. Sandwich authorities tired of handling whales and oil, and in 1659 they turned over to John Ellis the responsibility for the town's portion of what was becoming a lucrative business.

Edgartown on Martha's Vineyard started recording whaling items at this time. On April 16, 1653, a regulation was promulgated: "Ordered by the town that the whale is to be cut freely, four men at one time, and four men at another; and so every whale, beginning at the east end of the town."[149] William Weeks and Thomas Daggett had been chosen whale cutters the previous year.[150]

There were bound to be conflicts between towns. In 1659, the first identified controversy with Barnstable regarding whales appeared in Sandwich's records.

1659/60 The 21st of the 12th month…The Town at this time mutually agreed that whatever whale so ever Gods Providence casts in to our liberties, it is to be put to common stock, to be improved for their attainment of those things as the town has occasion—And also these if they be recovered, that are in controversy between us and Barnstable.[151]

The controversy wasn't settled and two years later it returned at a Sandwich town meeting: "2. Thomas Dexter and Edmund Freeman the younger are chosen by the town for to go to Plymouth with Barnstable men about the fish that is in difference between us, to make peaceable end of it."[152]

At thar time, no law stated when the oil had to be paid. There are many records of towns paying their barrel of oil, although some were rather late. On June 10, 1658, the colony treasurer's account noted, "Capt Josias Winslow, Lt Thomas Southworth, Edmond Hawes, Josias Cooke…four barrels of oyle 08:00:00."[153]

In 1660, Sandwich's agent, John Ellis, owed sixteen pounds' value of oil.[154] Five days later, the court felt that Sandwich and Yarmouth were still holding back, "more due to the countrey in oyle att Sandwich and Yarmouth 03:4:0."[155] John Ellis felt the pressure, "and the oyle sometimes resting in the hand of John Ellis, being now released; the fines for which it was taken are yet due, and not in the formencioned."[156]

Sandwich was not the only town with a slow payment system. Yarmouth also had to be pressured to make payments.[157] In 1665, the General Court took action against Yarmouth and Sandwich: "It is ordered by the Court, that Yarmouth is to pay a barrel of oyle to the Treasurer for the countrey for some whale they had; likewise John Ellis to pay for a whale hee had the sume of twenty shillings."[158]

Yarmouth didn't release money easily, even to ex-residents. In 1663, William Nickerson attempted to recover a share of the whales taken along the shore of Yarmouth. He complained "in an action of trespas on the case, to the damage of forty pounds, for withholding from him his shares of whale blubber, for seuerall yeares past."[159] The jury found for Yarmouth and fined Nickerson ten pounds in damages, as he was not living in Yarmouth at the time. He thought he had rights to the whales by being a taxpayer.

The phrase "several years past" indicates that this withholding had taken place for a number of years. This is the earliest Yarmouth record concerning drift whales. William Nickerson had first been in Yarmouth in 1641, and had moved to what is today Chatham in 1656. His suit could have extended back nearly seven years.

Eastham's records first mention whales in November 1660, when the town meeting

> ordered whosoever shall find a whale within this township and moves it if need require, & give notice to the Court and to his next neighbor shall have two shares for his paines, and soe everyone is to give notice to his next neighbor, & to meet at the first opportunity—By the two shares above mentioned, if he is a townsman and is to have a double share, if they're not they must have a single share.[160]

In 1660, the town looked for a better method of cutting up and distributing drift whales.

> It is now ordered yt any four men the town shall meet to cutt up any drift whale yt comes into their limits according to former agreement as is now ordered. Ralph Smith,[161] Jonathan Sparrow, Thomas Williams & William Walker[162] undertook to cut up the first fish. Nathaniel Mayo, John Mayo, Mark x x & John Doane undertook to cut up the second fish. Richard Higgins undertook to provide accompany for to cutt up the third fish.[163]

This was a different way of alternating responsibility for finding whales. However, Ralph Smith found the lure of gain outweighed his responsibility to work for the town. In 1661, he was fined twenty shillings for having lied about seeing a whale in the way of duty.[164]

The very next year, the town meeting again changed how oil was to be disposed of: "One half of the town to have one whale, and the other half of the town to have the second, and so for the future, as also it is already x x that the half of the town that lives

on the north part shall have the first whale, and if there should come at one time but half a whale, that should be equally divided to the whole."[165]

Eastham also traded land for the right to whales. In 1665, the town conveyed Sampson's Island (Potonumecot Island) to Sampson for his quarter right of drift whales found on town shores of what is now Wellfleet.[166]

Plymouth Colony continued to refine whaling laws. The colony's leaders realized that whaling could be even more profitable, and at the June 1661 meeting, the colony

> *now asserted that whales no longer belonged to towns, but instead were the property of the colony. Rather than claiming a one-barrel assessment and allowing the town the bulk of the oil, the General Court proposed to take the greater part for itself and pay the towns two hogsheads of oil as payment for processing it. If the towns refused this new arrangement, the Court authorized the colony's Treasurer to turn the whales over to someone else and allow the town two hogsheads of oil in exchange for permitting the renter access to the whale and supplying firewood to boil the blubber. The Court further intended to increase its share of the colony's whale oil by stipulating it was entitled to one half of any drift whale brought in from outside the town's one-mile limit.*[167]

One can only imagine the outrage that this new proposition must have caused. The law tried to prevent persons from another colony from taking fish or whales at Cape Cod. "It is enacted by the Court that noe stranger or forraigner shall Improve any of our lands at the Cape for the making of fish without libertie from the Government."[168]

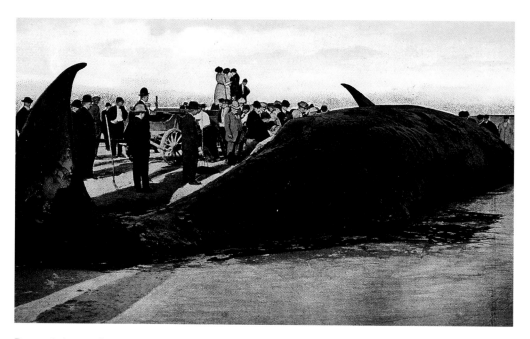

Postcard picture of enormous whale washed ashore in the nineteenth century. It was sold as a Cape Cod location, but other postcards state Ocean City, New Jersey, and Florida.

For the first time, people from Massachusetts Bay Colony were required to get approval from Plymouth Colony to take whales.

The colony got itself in hot water when it tried to increase its share. Feelings turned bitter, causing Plymouth Colony's treasurer, Constant Southworth, to write to Barnstable, Sandwich, Eastham and Yarmouth on October 1, 1661, with a proposition for sharing proceeds from drift whales. "Loveing friends," his letter began,

> If you will duely and trewly pay to the contrey [Plymouth Colony] for every whale that shall come, one hogshead of oyle att Boston, where I shall appoint, and that current and merchantable, without any charge or trouble to the countrey, I say, for peace and quietness sake you shall have it for this present season, leaveing you and the Election Court to settle it soe as it may bee to satisfaction on both sides.[169]

Starting the letter with "Loveing friends" attempted to limit the animosity, but it is evident when he wrote "for peace and quietness sake" that he was putting off a decision. Southworth's letter in fact included a 100 percent increase in the amount of oil to be given to the colony, as a "hogshead" replaced the earlier barrel. A hogshead was roughly two barrels of oil. His compromise was only intended as a temporary measure and Southworth suggested that the court of election should resolve the issue the following year.

No town accepted the principle that whales belonged to the colony and not the town. For unknown reasons, Yarmouth felt special pressure from Plymouth, and in January of 1662 they sent representatives to the court:

> The agents for the towne of Yarmouth appeering att this Court, according to agreement, to debate and determine a difference between them and others about whales, were desired by the Court to give in thire result conserning that matter unto the Court, as being that whereunto they would stand; who gave theire answare as followeth: …Wee intreat youer worshipes reddily to accept these few lines for a positive answare to which we promise to stand: that the Treasurer shall have the two barrels of oyle out of each whale.[170]

Signing the agreement for Yarmouth were Anthony Thacher, Robert Dennis, Thomas Boardman and Richard Taylor. This agreement referred only to the amount of oil, not the ownership of the whales.

Plymouth backed away from ownership of whales by never accepting Treasurer Southworth's ideas as outlined in his letter to the towns a year earlier. The status of 1662 remained in force until the end of Plymouth Colony's separate existence, thirty years later.

On June 3, 1662, the Plymouth General Court passed a new order reflecting how the towns should distribute their oil.

> That the townes where any [whale] shall come on shore may rent them for three yeares att the rate of two hogshead for a fish yearly to bee payed att Boston full and merchantable… there hath bine much controuersye occationed for want of a full and cleare settlement of matter relateing unto such whales as by Gods providence doe fall unto any pte of this

Jurisdiction…they [towns] *should agree to sett apart some pte of every such fish or oyle for the Incurragement of an able Godly Minnester amongst them.*[171]

Whales were called "fish" and were often referred to in that manner. The new regulation required that the oil be delivered to Boston, from where it could be shipped. Plymouth Colony had to use Boston Harbor, as Plymouth's was unable to handle the large vessels carrying oil to England.

MINISTERS

Payments to ministers from whale oil receipts first appeared in print in 1662. Ministers were hired by individual towns. It wasn't until the 1830s that total separation of church and state occurred in Massachusetts. On June 3, 1662, the court suggested, but did not mandate, that some of the oil be set aside for towns to pay ministers. Actually, oil as compensation occurred only in Eastham. Henry David Thoreau found this very interesting and included it in his book, *Cape Cod*.

> *In 1662, the Town of Eastham agreed that part of every whale cast on shore be apportioned for the support of the ministry. No doubt there seemed to be some propriety in thus leaving the support of the ministers to Providence, whose servants they are, and who alone rules the storms; for, when few whales were cast up, they might suspect that their worship was not acceptable. The ministers must have sat upon the cliffs in every storm, and watched the shore with anxiety.*[172]

Thoreau's sense of humor certainly showed in the way he dealt with this information!

In spite of the colony's suggestion, Yarmouth waited thirty years before addressing the issue of oil for the minister. At its July 22, 1692 town meeting, the following was announced:

> *At this Town Meeting also it was agreed and voted that hence forward ealy* [each] *and evary year al such whales, or ptes of whales or oyle fish, as by gods providence, shal be Cast upon any of the shores in this Townghip that doth of just Right belong to our Town shal be the Right and property of such parsons as shal be the settled allowed publycie Mister towards his yerly mantynance and if it shold so happen that by the providence of god more in any one year shold be Cast up their Comes to the allowed sum shal goe on towards the next yeares proporshon an so annually.*

Yarmouth wouldn't give the minister an extra share in any year, even if the "providence of god" brought in extra whales. One might surmise that it was an attempt to remove the minister. But the minister, Reverend Thomas Thornton, had been in Yarmouth thirty years and people called him "beloved." Thornton had been a leader in trying to Christianize the Indians.

Reverend Thornton was eighty-three years old when the town meeting denied him extra oil money. The following year (1693), he left the Yarmouth church to live in Boston. One wonders whether oil helped grease the skids in hastening his decision to retire and leave.

Sandwich waited even longer to give their minister a share of whale oil income. At the March 24, 1701/02 town meeting, "By their vote did give to Mr. Rowland Cotton all such drift whales as shall (during the time of his continuing in the work of the Ministry in Sandwich) be drove or cast on shore within the limits of said Town being such as shall not be killed by hands."[173] By 1702, few whales were drifting up on Sandwich shores.

One author described how Barnstable's minister was dealt with.

> In the old days, Sandy Neck was used as a try yard for whaling. There was a minister named Roland Cotton who complained because his salary was in arrears; the town fathers said he could have all the whales—"not killed by hand"—that were driven or cast ashore on Sandy Neck. There were so many that Mr. Cotton gave up preaching and spent his days trying.[174]

Unfortunately, this author did not cite the town records he used for this information.

Reverend Daniel Greenleaf of Yarmouth, who followed Thornton, was very friendly with Paul Dudley. Dudley wrote a very informative letter to British authorities regarding whales. Probably he received information about whales from Greenleaf. Greenleaf was invited to move to Chatham, in part based on his whaling knowledge. He didn't go.

Ministers knew that whaling was not a friendly occupation, but one filled with competition. "An early Eastham minister who, hearing the report that a whale was within sight of Nauset, abruptly ended his sermon, rushed down the aisle and joined the men who were about to race to the scene, shouting 'Now start fair!'"[175]

COOPERS

Along with ministers, coopers were important men in the community. Barrels had to be built that were sturdy enough to hold the oil without leaking and durable enough to be transported distances. After 1692, coopers had to mark their barrels identifying who made the barrel.

Probably the most well-known cooper of the era was John Savage, who planned to travel with Jacobus Loper to Nantucket. Loper never went, but Savage did. Three years later, his obligation to Nantucket fulfilled, Savage moved to Chatham.

> On or about the autumn of 1675, the Monomoit "neighborhood" was further increased by the arrival of two families from Nantucket, those of John Savage and Edward Cottle…And John Savage, who was a cooper, obtained the right to cut hoop poles on any of the common land owned by said Nickerson.[176]

Also from Nantucket, but not a contemporary of Savage, was Peleg Duch, whose inventory at the time he died in 1737 indicates he was a cooper.[177]

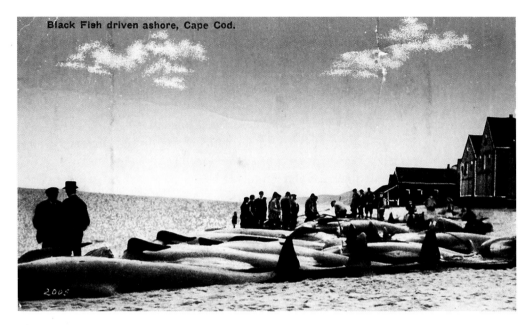

Black Fish driven ashore, Cape Cod.

Postcard picture of blackfish driven ashore at Cape Cod. This was in the nineteenth century, but date and location are unknown.

There were at least four known coopers in Barnstable. Joseph Hull was identified as a cooper in 1678[178] and John Crocker was identified in 1712.[179] James Paine Sr., freeman, who lived from 1655 to 1728, is listed as a cooper on a deed,[180] as is Zephon Ames, identified in a court document describing Ames's attempt to collect money from Silvan Bourn and John Otis of Barnstable in 1744.[181]

One of Yarmouth's founders was a cooper. Francis Baker (1611–1696) came to Yarmouth in 1641 and settled near today's Follins Pond. Colony records identify him as a cooper.[182] Another Yarmouth man, John Barnes, who died in 1671, left a "cooper adds [adz]" as well as other woodworking tools in his will.[183]

Gorham Phiney Jr. of Harwich is listed as a cooper on a deed dated 1757,[184] and Thomas Paine's father was a cooper in Eastham.[185] It is probable that there were several other coopers on the Cape whose names are not known.

1660s to King Philip's War

Whales sometimes appeared in Boston Harbor and the journal of Reverend Simon Bradstreet recorded the capture of a whale in Boston Harbor below the Castle in October 1668.[186] That same year, Jonathan Webbe was drowned in Boston Harbor catching a whale below the Castle. A line attached to the whale became wrapped around him and he was pulled out of the boat (it is unknown if this was the same whale reported by Reverend Bradstreet).[187]

Changing payment from a barrel to a hogshead in 1662 continued to rankle Plymouth Colony towns. Eight years after starting the controversy, the General Court reversed itself. "This Court doth order for the prevention of any discontent or controversy for the future and for a final Issue and settlement…the Countreys due of every such whale [drift whales] was altered from a hogshead to a barrel."[This was written as a side note on the law.][188]

In June of 1671, Samuel Matthews of Yarmouth was fined one pound for "sayleing from Yarmouth to Boston on ye Lords day."[189] While Matthews got caught, can one honestly believe that whalemen let whales escape just because they appeared on Sundays?

The following year, questions remained as to whether whales taken at sea were to be placed in the same category as those that drifted on shore. "In reference unto a whale brought on shore to Yarmouth from sea, the Court leaves it to the Treasurer to make abatement of what is due to the countrey thereof, by law, as hee shall see cause, when hee hath treated with those that brought it on shore."[190] The court took the easy way out; it had the treasurer and the whaleman settle the issue.

Whaling interests appeared in inventories of some Martha's Vineyard's estates at that time. "Richard Arey's estate in 1669 showed 'Half a Barrel of Oyl'…and 'great kittells' belonged to John Bland…An iron pot was listed in the inventory of John Gee."[191] In 1676, Thomas Mayhew's will stated, "A sixth part of whale, all aforesaid lands, fish & whale I do give to my daughter Martha."[192]

Other records show the prevalence of shore whaling at the Vineyard, and its inhabitants shared in the marketing of the oil. "One Indian sachem in selling his land reserved the right to 'four spans around the middle of every whale that comes upon the shore.' Lookouts and try houses became part of the landscape; proprietors transferred rights 'of fish and whale' with their deeds to land."[193]

It was during this time that Nantucket took its first steps toward creating a whaling economy. Prior to 1672 (and most likely after 1670), the first recorded whale came into Nantucket waters. Called a scragg by residents, it came into the harbor and remained three days. "This excited people, and led them to devise measures to prevent his return out of the harbor. They accordingly invented and caused to be wrought for them a harpoon, with which they attacked and killed the whale."[194]

Their need to "invent" a harpoon showed their need for training. Close ties existed with New York and Long Island, including Nantucket's identity as a part of that colony for a short period of time, and these led Nantucketers to invite a well-known Long Island whaleman, Jacobus Loper, to come train them. In 1672, the residents made an agreement with Loper.

> *5th. 4th. mo. 1672 James Lopar doth Ingage to carry on a design of whale Citching on the Island of Nantuckket, that is the said James Ingages to be a third in all respeckes, and som of the Town Ingage also to carrey on the other two thirds with him…and for the Incorragement of the said James Lopar the Town doth grant him Ten acres of Land in som convenant place, that he may Chuse in, (wood Land exceped) and also Liberty for the Commonage of the Cows and twenty sheep and one horse with necessary Wood and water for his use on Conditions that he follow the trade of whaleing on the Island two*

years in all the season thereof, beginning the first of March next insuing…the commonage is granted only for the time he stays here.

(Note—The word "design" is a seventeenth-century word that loosely translated means trip. The first recorded use the authors could find in America was in 1631 in *Bradford's Journal*.)

Loper never went to Nantucket. Cooper John Savage was the other person in the deal. Although he went to Nantucket, he stayed only three years before leaving for Chatham, which was then called Monomoit. It is obvious that Savage couldn't teach them enough, for in 1690, Nantucketers asked Ichabod Paddock from Yarmouth to come to train them.

During this period, Indian problems were foremost in colonists' thoughts. There had been a deterioration of relations between European settlers and Indians. In 1675, a brutal and costly war commenced, known as King Philip's War. No further regulations regarding whales were written for seventeen years. It wasn't that whaling was less important, but rather it seems that the laws extant at the time seemed to suffice.

AFTER KING PHILIP'S WAR TO DOMINION

The years between the end of King Philip's War and 1715 were glory years for shore whaling on Cape Cod. In 1676, Secretary Edward Randolph of Massachusetts, the British agent in Boston, wrote to the Lords of Trade of the great quantity of whale oil made in Plymouth Colony.[195] Two years later, Randolph again wrote about whales: "New Plimouth Colony have great profit by whale killing. I believe it will be one of our best returns, now beaver and peltry fayle us."[196]

Both of these letters were written before Plymouth was part of the Dominion of New England. The words showed how Massachusetts Bay men had taken to shore whaling, especially along Cape Cod's shores. An example of this appears in the Eastham records.

> *In November, 1678, a shallop sailed into one of the harbors of Monomoit, its master Moses Bartlett of Boston, having been taken ill on his voyage. His disease was found to be small pox, of which he died on the 15th of the month and was buried the same day. William Nickerson, Sen., and his son Nicholas of Yarmouth, took an inventory of Mr. Bartlett's effects and sent it to Plymouth. Besides the shallop, with rigging, sails, anchors, oars, &c., there was a chest of clothing, carpenter's tools, a hogshead of salt, a harping iron, a drawing knife, &c. Mr. Bartlett was evidently in search of whales.*

Men from Massachusetts Bay weren't always treated well by Cape Codders. In the Salem, Massachusetts records of 1692, one finds a letter John Higginson and Timothy Londell of Salem wrote to Nathaniel Thomas:

Sir, we have been jointly concerned in several whale voyages at Cape Cod, and have sustained great wrong and injury by the unjust dealing of the inhabitants of those parts, especially in two instances: ye first was when Woodbury and company, in our boates, in the winter of 1690, killed a large whale in Cape Cod harbor. She sank and after rose, went to sea with a harpoon, warp, etc. of ours, which have been found in the hands of Nicholas Eldridge. The second case is last winter, 1691. William Edds and company in one of our boates, struck a whale, which came ashore dead, and by ye evidence of the people of Cape Cod, was the very whale they killed. The whale was taken away by Thomas Smith of Eastham, and unjustly detained.[197]

The Smiths were again in trouble with the law, further enhancing their reputation.

Records of various Cape towns give more insight to this period. In Sandwich in 1677, in the inventory of the late John Ellis Jr.'s estate, half the total equity was in his whaleboat.[198] This is noteworthy, as it is the first mention in Sandwich of a boat used for whaling.

On January 27, 1680/81, the Sandwich town meeting dealt with another drift whale. "The Town made choice of Benjamin Hammond, Steven Skiff and Steven Wing to make sale of the whale that lately cast on shore in the most they can of it in the towns behalf, and for the towns use."[199]

That same year, the town meeting in February required, "Steven Skiff is ordered to pay his father twenty and five shillings out of that money as is in his hands as came from the treasurer, in lieu of a barrel of oil as the town promised Goodman Skiff."[200] Obviously, father and son relationships weren't always close, especially when money was involved!

In 1680, Barnstable established its leadership in the teaching of using whaleboats. That year, John Gorham of Barnstable invited Jacobus Loper to teach whaling. Loper was the same Long Island whaleman who had been invited to Nantucket eight years earlier, but never went. This time, Loper came. His arrival seems to be a benchmark for Cape Cod whalemen standardizing procedures.

In 1676, Eastham town records from the town meeting of January 29, 1675/76 show: "Whereas it appears to be some matter of debate between us and our neighbors of the other 3 towns namely Barnstable Sandwich & Yarmouth in reference to charges arising about the scouts kept on the farther side of Sandwich."[201]

This practice by Eastham men, and probably those from other towns and colonies as well, was bothersome to Yarmouth. At the town meeting of September 17, 1686, it was

ordered That no person belounging to any other Towne shal have Liberty to set up any Rendyvow with in our Township in order to Whale Catching upon the penalty and forfiture of ffive pounds pr week also that Non of our inhabytance shall give entertainment to such person above each and fforty howers ata time upon fforfytur of 10d pr Day except any of our Whale Company Do se Cause to imploy any such prson or prsones and such to secuer the Town the, on halfe of the said forfytuer to the informer and the other to the Towne for the towns use.[202]

Wast Book of John Gorham. Gorham described Loper as an old wizard. *Courtesy of Sturgis Library, Barnstable, Massachusetts.*

In Yarmouth, townwide organization for drift whales became better organized after King Philip's War. The town set up three groups of men to watch for whales: one "from Sawtuckett to Sawsuett harbors mouth," another from "Sawsuett to Yarmouths harbor [Bass Hole]" and the third from "Yarmouth harbor to the Mill Crick."[203] This organization came as a result of a whale being cast up near Sesuit Harbor, for further in the minutes it was recorded:

> *It was agreed by the Town that the whale that was by gods prydence, cast up at Sawsuett the Town have agreed that our Naighbores that have Cutt up the sayd whale should have on third and of the sayd Whale, and the Rest to be shard betwixt them and the Rest of the Town that have a Right to a share ther in and the barrel to the Cuntry to bepayd out of the whole whale and the Cutters have the bone.*

Someone questioned the share that each townsperson would receive. It was spelled out three months later at the May 11, 1679 town meeting: "Elij Hedg hath agreed, and doth ingag to pay 12d in mony to al thos that have a Right to a share ther in."

The next year, Edmond Hawes was one of four men who, "for four or five pounds a whale to be paid in blubber or oil, were to look out for and secure the town [of Yarmouth] all such whales as by God's providence shall be cast up in their several bounds."[204]

Records throughout the Cape indicate that men were engaged in whaling. The following are examples. On June 12, 1685, the Plymouth Colony treasurer recorded, "To received from Barnstable, pr acctt of a whale 00:12:00"[205] Eastham town records reflect, "About the 3d of November 1684 there was reported a whalefish ashore on the

Old spelling of Sesuit, showing the pronunciation. *Yarmouth town meeting records.*

backside [ocean beach] and that John Snow, Josiah Cook, and Stephen Hopkins had cutt it up."[206] They had to surrender the blubber to the town.

On Nantucket, a quitclaim of Akeamoug & Jacob Sons of Pattaconet gave land on Tuckanucket to James, Peter, John and Stephen Coffin on March 6, 1681. The quitclaim "disclaime any Right or Interest in any whale by virtue of the land on Tuckanucket Island."[207]

DOMINION OF NEW ENGLAND

During the Dominion of New England, from 1686 to 1689, few local records were kept. The Dominion restricted town meetings and Plymouth Colony lost its independence. Shore whaling remained an issue, however, for there was Dominion legislation in 1688 that stated, "Each company harping Iron & lance be Distinctly marked on ye heads & sockets with a poblick mark; to ye prevention of strife."[208] Creating a single colony did little to end the bickering over who owned a whale.

There is some information about marketing whale oil during this time, thanks to Samuel Sewall's diary. A famous judge of the Salem witchcraft trials, Sewall wrote in 1689 to John Mayo of Eastham: "When you were last att my house you spake of returning hither this winter Laden with oyll."[209] He also sent letters to Thomas Crosby and Samuel Smith. The whale oil was sent by Sewall to his agent in London, Edward Hull, who sold the oil at best profit. Sewall, a circuit judge, traveled throughout the Dominion on official business. During these travels, he clearly conducted his own private enterprises as well!

1689–1692

Plymouth Colony returned to brief independence after the Glorious Revolution in Britain, and the need arose for whaling legislation. To prevent shore whalemen from suing one another, a four-part law was passed on November 4, 1690.

Ordered, that for the prevention of contests and suits by whale killers—

1. This Court doth order, that all whales killed or wounded by any man & left at sea, sd whale killers that killed or wounded sd whale shall presently repaire to some prudent person whome the Court shall appoint, and there give in the wounds of sd whale, the time and place when and where killed or wounded…

2. All Whales brought or cast on shore shall be viewed by the person or his deputy [paraphrasing—this person had to record all wounds as well as time and place where the whale came ashore]

3. [no one can cut up a whale until it has been viewed or they lose the right to it]

4. [the first to find a drift whale not appearing to be killed by any man must pay Plymouth one hogshead of oil]

The court appointed specific whale viewers for each town. Unfortunately, some of the names on the document are illegible and the official record for some of these names simply is a series of *xxx*s.

The persons appointed by the Court to inspect and view the whales, pursuant to the Court order, on the other side mentioned, for their severall respective towns, are as followeth: for Plimouth, Thomas Faunce; for Sandwich, Mr. Stephen Skeff; for Barnstable, Capt. Joseph Lothrop; for Yarmouth, Capt. x x; for Eastham, Major John Freeman; for Monamoy, William Nickarson; [for Succonessett,] *Jonathan Hatch, Senr; for Duxborough, John Wadsworth; for x, x x; for Scituate, Saml Clapp.*[210]

With Andros gone, town records again appear. At the November 5, 1689 Yarmouth town meeting, "thos men formarly ordered to Cut up and secur the whales that be long to the Town shall have from hence forward but forty shillings for ech whale Cut up and secuared and to give the towns men spey Notis to take care of it."[211]

Plymouth Colony records noted, "1691 Nathl Baker Yarmouth whalebone 00-00-06."[212] This was payment by the town to the colony. The town sold its oil and whalebone, and the November 6, 1691 Yarmouth town meeting confirmed this: "Agreed that Joseph Rider Cunstell [constable], and Mr. Jose Howes shold in the be halfe of the town take the oyle that is belonging to the Town Now in the hands of Mr Joseph Howses to take order and Care for the sending and Transporting the sayd oyle and Whale bone to boston to be sold for mony."[213]

During these years, one of the more famous whaling taverns was built on Great Island in present-day Wellfleet and Nantucket took its first steps toward becoming a whaling giant. Having been rebuffed by Jacobus (James) Loper in the 1670s, Nantucket now turned to a Yarmouth man. In 1690, they requested that Ichabod Paddock come to the island. Paddock, who had learned the intricacies of whaleboats during Loper's visit to Barnstable, was well known along the entire shore of Cape Cod Bay. He frequented the Truro area so often in search of whales that some Truro histories relate that he was from that section.

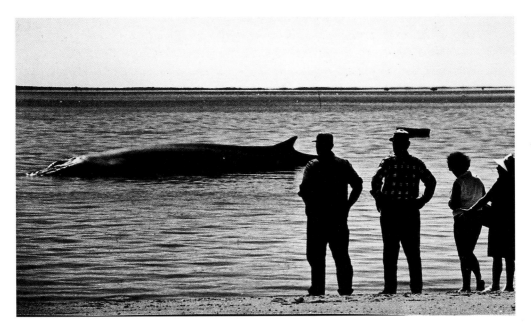

Postcard picture of sixty-one-foot finback at Wellfleet Harbor. It is low tide.

Nantucket's early settlers made use of Indian help. They hired, and later acquired through indenture, Indians to row their vessels. "The white Nantucketers who launched the shore fishery in the 1690s were certain about two things. First, though they agreed to participate in the actual chase as steersmen or harpooners, they refused the menial labor of manning the oars…The second point on which the English insisted was that they retain complete control of the industry themselves."[214] The real barrier to native investment in shore whaling was the Indians' reputation for unreliability.[215] This is discussed in more detail in the chapter on Indians and whaling.

In the early 1690s, white inhabitants of Nantucket purchased strips of "shoreside land that more than thirty years of drift whaling (or at least the observation of Indian drift whaling) had taught them were prime spots for hunting whales."[216] There is consensus that Paddock played a part in setting up four districts on the south shore.

On Martha's Vineyard, whaling wasn't as big an operation, but still people were appointed to serve specific functions. Mr. Sarson and William Vinson were appointed by the "proprietors of the whale" to oversee the cutting and sharing of all whales cast on shore within the bounds of Edgartown, "they to have as much for their care as one cutter."[217]

MASSACHUSETTS BAY COLONY, 1692–1715

When Massachusetts Bay and Plymouth Colonies joined in 1691, the province charter of Massachusetts Bay mentioned whales

and free Libertie of Fishing in or within any of the Rivers and Waters within the bounds and limits aforesaid and the Seas thereunto adjoining and of all Fishes Royall Fishes Whales Balene Sturgeon and other Fishes of what kind or nature soever…Our Letters Patents shall not in any manner Enure or be taken to abridge bar or hinder any of our loveing Subjects whatsoever to use and exercise the Trade of Fishing upon the Coasts of New England.

Boston was the largest of the American cities at the time, and Plymouth now played a secondary role in the colony. Life in Boston was anything but romantic. A smallpox epidemic roared through in 1690. A large fire that same year, coupled with one the following year, devastated large segments of the peninsula, and a drought in 1691 caused severe shortages of food in Boston into 1692.[218]

City life was hard. Window glass was scarce and most residents preferred small, compact, heatable houses. These houses had no insulation and used copious amounts of wood for fuel, which became scarce during winter. For most, the kitchen was the only heated room. Potable water was difficult to find, and wells were often fouled. "Outhouses, slop jars, and open sewers in the middle of each street supplied the principal means for maintaining domestic hygiene at a relatively tolerable but nonetheless pungent level."[219]

The city supported at least a dozen rum distilleries. With lead pipes used in distilling, health conditions were further compromised. Still, rum gave the consumers a way to forget about other things. The harbor must have felt the pollution, but nevertheless, in 1707 a whale, forty feet long, entered Boston Harbor and was killed near Noddle's Island.[220]

It was during this period of time that shore whaling reaped some of its greatest successes. In the winter of 1699–1700, twenty-nine whales were taken before the end of January.[221] Cotton Mather wrote in his journal about "our numerous tribe of Whale-Catchers."[222] The regulations in use at Plymouth applied to both former colonies, and the finders had to pay a hogshead of oil to the Massachusetts Bay Colony government. Most whaling still was taking place south of the city.

After the colonies combined, Sandwich records continue to show interest in whaling. Whaleboats appear more frequently in their records, including this record from the town meeting of November 9, 1693:

Town did then order and appoint their trusty Friends Samuel Prince and Thomas Smith both of said Town, Gentlemen, their agents to defend the said Towns right and interest in the whale fish or part of a fish which came on shore at the Town Neck Beach in said Town of Sandwich in the month of October last past that was seized for their Majesties by William Basset Sheriff of this County of Barnstable…for the obtaining and defending the said Towns right in said Whale fish or part of a fish and all other whales or part of such fish that shall come or be cast on shore within the limits of our Town of Sandwich.[223]

The town's process for dealing with whales did not always function smoothly, according to this record of January 22, 1693/94:

Samuel Prince…resolved that he would not act as an agent with Thomas Smith with whom the Town hath lately chosen and deputied him to act as an agent to defend the Towns interest in the whale fish or part of a fish that was cast on shore in the Town Neck in the month of October last past which was seized by the Sheriff of this County.[224]

We'll never know what caused Samuel to refuse to work with Thomas Smith. Is this more grist in the Smith family lore of being a difficult family?

Other Sandwich records reflected lucrative times. "[March 20, 1694/95] And also to receive of Mr. Stephen Skeffe and Thomas Smith what monies or produce of a whale that some time since was cast on shore at the Town neck in aid Sandwich which belongs to the Town."[225]

Probate court records also show a strong whaling influence in Sandwich. Samuel Wing, Joseph Fish and Joshua Badhouse of Sandwhich all had shares in whaleboats, while Caleb Nye and William Swift had "bones & oyl."[226]

Barnstable was enjoying major whaling successes, and controversy came with these successes. One of the major issues concerned who had the right to use Sandy Neck.

In the years between 1694 and 1703 there was a great deal of suing for the right to use the Great Marshes, which were then called Moskeehuckgut…Abner Hersey owned a great deal of the marsh area…The back beach was also set aside for any citizen of the town who wanted a fish house, hence the name "Common Fields."[227]

John Otis built a warehouse on Barnstable Harbor at Rendezvous Creek in 1696 to house the whale oil.[228]

Probate court records show that Joseph Holley, John Fuller [who was a "Chirungiun," or surgeon], Thomas Allin and Captain Thomas Dimmuck all owned shares in whaleboats, while Jabez Crocker and James Gorham had Indian "servants."[229] John Baxter, "whaler," sold his share of a mill to his uncle Shubael Gorham.[230] This identifies another whaleman from Barnstable and points out that all whalemen had other jobs during the non-whaling season.

Barnstable's fleet had seven vessels totaling 170 tons by 1713. John Otis was the leading merchant and his journals recorded whale oil being carried by his vessels to Boston.[231]

The use of Sandy Neck was the major issue for Barnstable. During the winter whaling season, more than two hundred men lived out there. One attempt to resolve problems took place at the Barnstable proprietors meeting on February 16, 1714/15. A wide strip along the whole back of Sandy Neck was reserved for the free use of citizens who wanted to build whale houses there. Four other places on the Neck were reserved as try yards, one of them about a quarter of a mile west of Braley's. [Braley's is a sand dune named for Braley Jenkins, a cranberry grower. It lies north of Big Thacher Island.][232]

The four places for try yards were established by the proprietors at their April 1715 meeting.

On April 11 of 1715, voted and confirmed…Yt Sandie neck be Layed out into Sixty Lots As equal in value as may bee for Quantity & Quality…& use of four spots or pesses for the seting up four Try houses of about half an acre to each for ye Laying blubber barrils wood & other nessesceries for ye trying of oyl as need may Requir Reseruing or Leauing all Convenient waies pticulerly waies from ye twenty Rods Rserued on ye north shoare to sd try houses & so down to ye south shoare for Landing bots & tacking of oyl & what els may be nessescary.[233]

This description noted that one half-acre of land was needed for try houses and yards. The sixty lots were established after this meeting and owners chosen by lot. The actual division took place in September of the next year, an indication of the difficulty encountered in establishing sixty equal lots.

The list of lot owners provides fascinating insight into the names of actual whalemen, although it is obvious that some of the names were businessmen, intent on making sure they weren't left out. It is doubtful that Colonel John Otis actually went out in a whaleboat. Evidence of whaling still exists on Sandy Neck, with large bands of charcoal in the sand dunes, along with bricks from the try yards. Whalebone vertebrae have been found and photographed.[234]

Yarmouth lost Ichabod Paddock to Nantucket, but whaling continued. Lookouts were appointed for drift whales at the October 5, 1692 town meeting. In 1697, Cotton Mather mentioned one cow whale fifty-five feet long and a twenty-foot calf caught in Yarmouth.[235] As was the case for Sandwich and Barnstable, Yarmouth's probate court records indicate who were whalemen and what they owned. The number of records indicating some form of whaling is staggering; most people had a connection with this industry.

Joseph Hawes, Thomas Howes, Jeromiah Howes, John Casley and Samuel Howes all owned shares in whaleboats. Thomas Howes had forty-two Indians indebted to him, plus he owned two black girls worth forty-one pounds and an Indian boy (possibly an indenture) worth five pounds. Temperance Baxter owned two mulatto boys worth sixty pounds. John Ryder owned marsh on Grays Beach, and this is one of the earlier records identifying the beach at Bass Hole as Grays Beach.[236]

Yarmouth proprietors made the decision to keep their whaling land under common ownership, even before Barnstable divided up its land on Sandy Neck. This appears to

Document calling John Baxter a "whaler." This was not usually done, as they were known as "whalemen." *Courtesy of John Braginton-Smith.*

have been a satisfactory arrangement, although the total area of land was smaller than Sandy Neck. At the July 1, 1713 proprietors meeting, "it was then Voted & agreed upon by this proprietors that a piece of Land & beach Lying Near Coy pond belonging to ye Proprietor in yarmouth Containing about 2 acres but it more or less: Shall for ever Ly undivided for ye benefit of ye whale men of this town of yarmouth."[237]

The land was known as "Black Earth." While this is the first formal record of the setting out of a whaling land, the area had been in use for a number of years.

When Yarmouth and Dennis separated as independent towns in 1793, this whaling land was set aside for both towns. It was even written into the perambulation of bounds. There was still some whaling taking place, so it was included in the document. A petition to "leave to Withdraw" was reported to the state legislature in 1846, but the legislature took the ground that this was a matter over which it had no control.[238]

The land was finally disposed of on February 14, 1876, when town meetings in both towns authorized the selectmen to sell whaling lands. The land auction was advertised in the *Yarmouth Register* on May 20, 1876. A map was drawn, but never recorded at the Barnstable County Registry of Deeds. The approximate location was waterfront property north and northwest of buildings marked "Cape Cod Bay Ho. JM Lufkin, Prop" on an 1880 map of Dennis.

A 1714 Yarmouth document recorded the names and shares of men in one particular whaleboat company. All six men in the crew are mentioned.

1714 To John and Jonathan Howes and Company for whale cow	*10-00-00*
To Ebenr Howe for whale cow	*03-04-08*
To Saml Eldredge for whale cow	*03-04-08*
Jeremy Hows Sr for whale bone	*00-16-08*
Saml Hows for Oyle	*01-06-06*[239]

A 1715 Yarmouth document gave rare insight to the costs associated with turning a captured whale into oil and whalebone. Sandwich hired Nathaniel Howes to process a drift whale.

Yarmouth Feb the 21 day 1714/15

	Charges
The Sandwich whale	
to Cuting Said whale	*05-09-0*
to barrels 9 att 12/per lb	*05-08-0*
to trying	*04-16-0*
to one lode of wood	*00-10-0*
to Carting oyl bord Sloop	*00-15-0*
to full binding barrels	*01-11-6*
to Nathaniel Howes trobel	*00-10-0 of old tenor*
rec'd of Nathaniel Howes	*115-08-9*[240]

Probate court records contain many Harwich records pertaining to whaling. Most of these are North Harwich (now Brewster) records. Thomas Crosby and Joseph Paine owned shares in whaleboats, and Miriam Wing owned whale rights in Eastham Harbor.

In 1715, Thomas Quanset, a Harwich Indian, left a probate indicating that he was a whaleman and was owed money from several others, most of whom were Indians.

To the efforts of a small whale voyage in Thom Riches Hands…

Due to estate from Jabez Jacob	*00-13-00*
" *John Daniel*	*00-06-00*
" *Joshua Ralph*	*00-08-00*
" *Joseph Moses*	*00-02-02*
" *Isaac George*	*00-02-00*
" *Jabez Twinning*	*00-10-00*
" *James Francis*	*00-02-00*
" *Mary Crow*	*00-05-04*
" *Job Menasies*	*00-05-04*[241]

Eastham's probate records also indicate great involvement in whaling. Many mention the landmark Hog's Back. Another property "lyeth betwixt the land of Thomas Mulford, next to Hog's Back, and the land of Thomas Mulford next to the Pond, on the southerly side of Pamet great River."[242]

Some probate records were written by Samuel Smith, the well-known whaleman. Perhaps other whalemen were not literate enough to write their inventory. Lieutenant Jabez Snow, John Fuller [also a surgeon], John Snow, John Harding and Samuel Smith all owned shares in whaleboats. Samuel Smith owned four try pots and Indian debts worth £853. [243]

In 1697, a compact was recorded that allowed Indians one-eighth of all drift whales on both shores.[244] While the back (Atlantic) side had fewer whales, there are instances of whales there. Kittredge wrote, "In the winter of 1933, a big finback shattered tradition by coming in on the outside of Monomy."[245] More recently, in December 2004, a dead humpback whale came ashore at Newcomb Hollow in Wellfleet.

In 1704, Eastham allowed lot owners on Lieutenant's Island right-of-way passage across one another's land to cart wood and water to their whale houses. The island was no longer reserved for support of the minister, but was opened to private grants.[246]

In this same year, an unusual petition/patent application appeared in Boston regarding the manufacture and supply of saltpeter. Two Eastham men and one man from Nantucket requested, "Thomas Houghton of Boston to take away the leftover whale after blubber stripped, and not let any others do it." The council granted the patent for four years and required that Houghton show satisfaction "for the rayseing of Salt Petre to supply the province."[247]

In the notes pertaining to this, only the lean of the whale was to be used. The "lean" was what was left after the blubber and whalebone (baleen) had been taken. In most cases the lean and skeleton were left to rot and wash away, although sometimes they were

used for fertilizer. Interestingly, one use for the lean was crossed out. That part was for "Indians and Swyne to eat." The law required eight shillings to be paid for every lean whale cut up. Four reasons were given to support passage:

1. Barrels will be needed so coopers will have more work.
2. Houses will need to be built and people "imployd" to cut up whales.
3. It will "imploy our sloopes to cary it to Boston."
4. If it is exported, it will be an advantage to Boston.

Another draft petition was written that stated, "Thomas Houghton shal pay to every whale man one shilling in mony acknowledgement for each of their several shares in the Lean of the whale fishes that they shal take." This replaced the eight-shilling figure. This petition was signed by "Samll Treat Senr, Samll Knowles, David Melvill, Samll Freeman Ju, Jona Sparrow, Richard Sparrow and Richard Godfree."

The bill failed in the first vote of the house because the period of years was too long. Questions were raised regarding a "New Invented Gun, called ye whale Gun, or a new invented Lamp, called ye whale Lamp." There is no other information about these. Houghton agreed to demonstrate the practicality of his invention within five years or forfeit his monopoly, and the House agreed. The bill passed December 5, 1706, concurred in and consented to by the governor.[248]

It is only briefly mentioned how Houghton planned to produce saltpeter. In a note to the governor on November 20, 1706, Houghton stated, "I intend to use some part of it [lean of the whale] mixt with other Things to make Salt petre."[249] There is no evidence that he made saltpeter out of the lean of the whale. The Eastham men wanted this bill to pass because they would be paid for the lean, something that in the past had been of little monetary value.

Eastham faced the same problems as Barnstable, Sandwich and Yarmouth regarding other towns' whaleboat companies in their waters. Between 1707 and 1712, Eastham grappled with ways to enforce regulations passed at the town meeting,

> which enacted regulations on the landing of whaling boats on both islands and the cutting of wood by crews. In order to tax the "foreigners" from other towns who were profiting from the Billingsgate whale fishery, it was voted that the harpooner or steersman of each boat was to pay two shillings fore every member of his crew who was not an inhabitant of the town of Eastham, whether he be English or Indian.[250]

Enforcement proved impossible. In 1708, John Paine was instructed to see that the regulations were obeyed. In 1710, Isaac Pepper was appointed for two years and promised one quarter of all fees he collected. Finally, in 1712, the town meeting "abandoned the attempt at enforcement and voted 'that there should be no persons persecuted in the law in the town's behalf for any arrearage not paid by persons sitting down [searching/waiting for whales] at Great Island at Billingsgate on whaling voyages.'"[251]

In 1709, the north part of Eastham became a separate town known as Truro, but boundary lines weren't established until 1712. One bound was at Cormorant Hill at a jawbone of a whale.[252]

In 1715, Eastham subdivided Great Island, the location of many whaling houses and Smith's Tavern. "Whaling boats manned by inhabitants had been free to bring blackfish or other whales ashore anywhere on its beaches to try blubber over fires."[253] It is interesting to note that Barnstable, Yarmouth and Eastham dealt with ownership of whaling lands within two years of one another, 1713 and 1715.

Farther down the coast lay the tip of Cape Cod. Although permanent European settlement began there about 1670, the area was lawless for a half-century.[254] A hamlet between Race Point and Wood End was known as "Hell Town" and the harbor was "Tophet's Mouth"—a Biblical term likewise denoting hell. Another landmark was "Good Rum Point." By 1714, Hell Town had grown so lively that Truro was ordered by the General Court of Massachusetts to provide local law enforcement—an honor it vigorously protested.[255] The area was supposedly in union with Truro. Truro petitioned against this in 1715, knowing the difficulty in controlling it.

There had been many efforts to deal with the lawlessness. By 1705, there were 130 men there. This number shrank after the whaling season, but some remained to fish the bountiful waters there. Fortunately, there still exists a copy of a 1705 letter sent to Governor Paul Dudley by William Clapp.

CAP COD, July 13th, 1705
SQUIER DVDLY,

Sir;—After all due sarvis and Respecks to your honor wishing you all hapynes boath hear and hear after I mack bould to inform your honor that I have liveed hear at the Cap this 4 year and I have very often every year sein that her maiesty has been very much wronged of har dues by these contry peple and other whall men as coms hear a whalen every year which tacks up drift whals which was neuer killed by any man which fish I understand belongest to har magiesty and had I power I could have seased severl every year and lickwies very often hear is oportunyty to seas vesets and goods which are upon a smoglen acompt I believe had ia comishon so to do I could have seased a catch this last weak which had most of thar men out landish men I judge porteges she lay hear a week and asloop I beleve did thar bisnes for them: sir I shall be very Redy to sarvef har magisty in Either of thes or any thing els that I may be counted worthy if your honor see case to precure a commishon of his Exalency for me with in strocktions I shall by the help of god be very faithful in my ofes one thing mor I mack bold to inform your honnor that hear are a gret meny men which goes fishing at this harbor and som times the French comes-hear and then every one rous his way because they have no one to heed them I my self haue ben a souferar since I liveed hear being cared a way by a small slop and hear was 130 men and severl brave sloops and no hand a capt about 12 miles distance. But we may be all tacken at the Cap and he no nothing of it I levef it to your honors consideration and mack bold to subscribe my self your hombled and unworthy sarvnt

WM CLAPP

Sir I am astranger to your self but if you plese to inquier of Capt Soethwark ann he can in form your honnor whether I am capebel of any such sarvis.

To the honored Mr. Pall Dodly Eisquier att Boston

The letter is indorsed by the Gov'r—a Commission for William Clap, Lt. At the Cape—
Warrant to prize drift whales, a water baylif.—Letter from the Custom House.—Lives
at Cape Codd.[256]

This is a rare look into living conditions then existing on Cape Cod. Lawlessness, smuggling
and French interference are colored with highly inventive spelling and grammar!

Probate court records reflect a few whalemen from Provincetown whose inventories at
their time of death included various and sundry whaling items. The reason there were
not more is that many men went there for whales but did not reside there permanently.

Chatham, incorporated in 1712, was the only Cape town totally on the Atlantic. It
was threatened by French privateers sailing in nearby waters during much of the era
when shore whaling was taking place. Lack of a minister, three migrations of settlers
leaving the town and a smallpox epidemic hurt Chatham's ability to organize and
conduct large-scale whaling. Even Governor Dudley realized the problem of French
privateers. On January 26, 1712, he ordered no man be "impressed" for military service
from this area, due to the danger from the French.[257]

Chatham's unordained preacher was Jonathan Vickery. On April 30, 1702, Vickery
went out in a boat with a group of local people, perhaps looking for whales. The
reason for "perhaps" is that the end of April is late for whaling. The boat capsized and
all drowned. With Vickery were Lieutenant Nicholas Eldredge, William Cahoon and
Edward Small.[258] William Cahoon owned shares in a whaleboat and Nicholas Eldredge's
inventory after death showed he owned half a share in a whaleboat. Now without a
minister, the town was unable to incorporate.

After Vickery's death, Chatham tried to lure Reverend Greenleaf from Yarmouth.
"The town voted to exempt from taxation both land, boats and men, in case Mr. Daniel
Greenleaf of Yarmouth should purchase a piece of land at Monomoit convenient for
'feshery' and should set forth a boat or more, not exceeding three, on that design. The
'feshery' referred to whale fishing. Greenleaf didn't come."[259]

The town's 1711 petition to the General Court of Massachusetts to incorporate
included "it being generally the Best Land of any Town on the Whole Cape, How
Likewise It has the most Pleasant Situation & Incomparable Conveniency for most
Sorts of Fishery." [Whaling was considered fishery.] Even with this glowing description,
Chatham had troubles finding a minister.

On Nantucket, whaling had become a very important winter vocation. "There were in
1700, 300 English and 800 Indians on the island…that population would have provided 60
English and 160 Indians males as potential whale fishermen. These estimations indicate that
nearly the whole able-bodied male population, English and Indian, must have been involved
in along-shore whaling at the early period."[260] The time since Ichabod Paddock had been
used to advantage, and the south shore of Nantucket had at least four major whaling areas.

In 1712 an event (which may have been fictional) changed Nantucket's destiny. That
year, Christopher Hussey and his crew, aboard a small sloop, were blown out to sea.

When the storm abated, they spied a sperm whale, harpooned it and dragged it back to Nantucket. This event has been hailed as the start of pelagic or off-shore whaling. Many on Nantucket do not believe the story, as no one by this name exists in the Hussey genealogy that fits this time frame.

Martha's Vineyard played second fiddle to the exploits of her neighboring island. Whaling was important enough to the Vineyard to warrant its share of disputes. In 1692, a whale came ashore at Edgartown. It was claimed by Benjamin Smith and Joseph Norton, but was also claimed by "John Steel, harpooner, on a whale design, as being killed by him."[261]

Court records document other controversies. Three whales were killed and they were identified by the location of harpoon, lance and knife marks.

> *The marks of the whales killed by John Butler and Thomas Lothrop—one whale lanced near or over the shoulder blade, near the left shoulder blade only;—Another killed with an iron for ward in the left side marks SS; and upon the right side marked with a pocket knife T.L.;—And the other an iron hole over the right shoulder blade, with two lance holes in the same side, one in the belly. These whales were all killed about the middle of February last past; all great whales between six and seven and eight foot bone, which are all gone from us. A true account given by John Butler from us and recorded.*[262]

John Butler has been identified as the first Vineyard whaleman of note. "For some time prior to 1700, he carried on whaling in the shoals and kept his try house busy. An Edgartown record shows Butler to have made several catches between 1702–3."[263]

ENVIRONMENT

Environmental concerns came to the forefront during this period. They were fostered by self-preservation. Trees were disappearing, having been used for fuel and building. With their depletion, sands began to migrate onto formerly forested areas and threatened harbors.

In 1663, Nantucket became the first town to regulate wood. Nantucket had little wood to begin with,[264] and the town meeting of that year voted that no wood was to be cut or used on Cowatu except for building houses. Violation of this regulation carried a ten-shilling fine.[265]

Towns protecting their wood supply proved to be a recurrent theme. Eastham passed early legislation regarding wood. In 1671, it forbid having wood cut and carried from the town.[266] Tisbury, on Martha's Vineyard, voted at its October 17, 1687 town meeting, "No parson or parsons shall carry…aney wood or timber out of the boundes of…lands belonging to this town."[267]

Nantucket was the first to mention limits on wood pertaining to whaling. Town records of March 1694 record a penalty for cutting cedar unless it was to be used for "whale bots or the like."

Proprietors of Pamet lands, known today as Truro, ordered in 1696 "that henceforth there would be no cordwood or timber cut upon any of the common or undivided land…penalty

of 15s for every cord, payable to proprietors."[268] In 1701, these proprietors tried to deal with whalemen, many from other towns, who were using common lands for whale houses.

> *Made choice of Constant Freeman and Benjamin Smalley to look after all such men as shall come from other parts…and to look after such persons as shall set up Whale houses, or other houses upon any of the common or undivided lands belonging to Pamet; or that shall cut wood or timber upon the same, or any part or parcel thereof;…for not less than one shilling a man; or otherwise to warn them to depart off from said land. Attest, Tho: Paine. Clerk* [269]

Yarmouth was more direct. At the town meeting on February 6, 1706, it specifically identified men from Barnstable who had been stealing wood. The town agreed to back its people if a suit were placed against them. Yarmouth men were given permission to use force and would receive town backing.

> *The town did proas to Stand by Sargan Jonathan halet Sargant John halet and Sarg Joseph hawes, or ether of them as to what Charg or damag mey arise on them by vertu of the Sute of any of the inhabbatents of barnstabel who have or mey at any time be found to be trespassing With in our towns bound by cutting or carting aweay our wood the halets and Joseph hawes being implied by our town to take the most advisabell cors they can to secure our Wood from being priveatly caread out of town by said Barnstabel men.* [270]

In 1711, Barnstable protected its wood from strangers. "That every stranger both English and Indians yt shall come and settle at Sandy Neck to goe on whaling Voiages and not having interest themselves shall pay for their fire wood each person three shillings at entry…This is understood not to Comprehend town inhabitants."[271] The proprietors feared losing the trees would cause sand to blow into the harbor.

By 1711, Wellfleet's Great Island and the surrounding area were devoid of wood. "Furthermore the town meeting had voted in 1711 that lot owners were to be free to pass over one another's land to cart wood and water to their whale houses."[272]

Yarmouth town record authorizing the use of force to stop Barnstable men from taking wood.

The General Court of Massachusetts was concerned. It was worried about the environmental damage whalemen were causing to the harbor at the tip of Cape Cod. As a result, the Massachusetts Bay General Court passed the following act on May 26, 1714:

> *Chapter 5—An Act for preserving the Harbour at Cape Cod, and Regulating the Inhabitants and Sojourners there….No person may presume to Bark or Box any Pine Tree or Trees…for the drawing of turpentine.* [A fine of 10 shillings is charged to] *keep the Sand from being driven into the Harbour by the Wind…Be it further enacted, that all and every person or persons coming to Abide and Sojourn there on Fishing or Whaling voyages, during his and their Continuance and Abode there, shall Pay four pence per man per week Weekly, shall be paid by the master of the Voyage or Boat, for his whole Company.*[273]

In 1714, the Massachusetts General Court established "Province Lands" to protect the remaining trees. The destruction of trees had allowed sand to migrate into the harbor. Through this act, province lands became some of the earliest conservation areas in America. The land is still called province lands in the Cape Cod National Seashore.

In a 1733 vote, the town of Barnstable further regulated use of wood:

> *Voted as followeth—about allowing horses & neat cattle to graze at Sandy Neck—Long since requested to the public use of sd town principally to accommodate the whaling designs…Was found to be very prejudicial to the town…by grass being Fed short & the Sand trod loose…and also from under the whale houses to the Overthrow of Several of them.*[274]

Obviously, the whale houses still were being used.

Environmental concerns continued into the 1740s, even as whaling declined. An act was placed by James Otis before the Massachusetts Council "to prevent the destruction of the Meadow called Sandy Neck…and for Better preservation of the harbor there."[275] Otis conveniently failed to mention that he and his family owned a fleet of vessels that used this harbor, and they owned a warehouse near Rendezvous Creek in Barnstable Harbor.

HARD TIMES

The 1720s found Boston still suffering. The town had endured several great fires. A smallpox epidemic in 1721, followed by another in 1730, killed nearly two thousand inhabitants. Some shipmasters even started going to neighboring ports, such as Salem. A paper money controversy hurt economic times, and a newspaper, the *New England Courant*, edited by Ben Franklin's brother, conducted a running battle with the established clergy.

Throughout colony waters, whales were becoming scarce. The lack of new whaling laws after 1725 reflects that whaling changed from a land-based enterprise to vessels searching worldwide for their prey. More boats chasing fewer whales led to arguments about ownership. An increase in court cases reflected the scarcity. Having to travel to

Three years later Chatham considered building a new meetinghouse. Many in the town asked for a delay because both crops and fishing (whaling) had failed.[301] The following year the meetinghouse in Chatham was pulled down and a new one was erected. "It was observed that the success of our Fishing the last year is wonderful."[302] This action demonstrated just how important the sea was in the economy of a Cape town.

In 1730, a Chatham crew drowned near Billingsgate on New Year's Day. "Whaleboat overset going back to Chatham from Hogback in Truro—crew Harpineer, 4 oarsmen, steersman all lost near Billingsgate."[303] The victims weren't identified.

By 1746, few whales were being caught. In that year, not more than three or four whales were caught on Cape Cod.[304]

More whales remained later around Nantucket. The high point of shore whaling on Nantucket was reached in 1726. During that year, eighty-six whales were taken by boats from shore.[305] Obed Macy claimed that shore whaling continued at Nantucket until 1760. The Cape found its supply failing long before.[306]

Macy mentioned that no men were killed while shore whaling. "It may be remarked that notwithstanding it [shore whaling] was a new business and the Inhabitants had it all to learn by experience that in the 70 years preceding 1760 not one white person [this does not include Indians] was killed or drowned, in pursuing the whaling business from shore." Interestingly, two pages later, Macy lists men living in Nantucket who had been killed by whales. Three were killed before 1760: 1732, Silas Paddack; 1749, David Upham, son of Jonathan; and 1759, Joseph Gardner. Not Indian names, one must conclude that these men where killed while engaged in off-shore whaling.

A 1758 document mentioned a winter whale being sold by Peter Micah, an Indian whaleman, for £242. The whale was sold by Joseph Rotch, and he was charged five barrels for trying.[307]

In an interesting sidelight, Nantucket whale oil impacted events leading up to the American Revolution. In 1773, the vessels *Dartmouth*, *Beaver* and *Eleanor* left from Nantucket for London filled with whale oil from off-shore whaling. In London, they were loaded with tea and became the vessels of the famous Boston Tea Party.

On Martha's Vineyard, court records reflect more cases as whales became scarce. The court records of 1724 contain the proceedings in a suit begun by Pain Mayhew Jr. against Jabez Lumbert of Barnstable, whale fisherman, concerning an agreement made that year as to a joint whaling trip in Barnstable Bay [now Cape Cod Bay], between Cape Cod [now Provincetown] and Boston, which was referred to as a "great voyage."[308] The next year, Samuel Merry, John Tilton and four others took a whale near Noman's Land that yielded twenty-six barrels of oil.[309]

Throughout the Cape and islands area, the number of whales diminished. Shore whaling was no longer a thriving winter industry. However, many blackfish were being taken during this time, used for both oil and food.

Jeremiah Hatch of Truro made sure he had sufficient rum while he was whaling in 1723. He and Joseph Jenkins brought a gallon and a pint for a "design."[293]

One whale design off Truro in 1725 had a dispute, and those involved went to the town clerk rather than to court. A Barnstable man told Truro's town clerk that he and his men were the first to strike a whale off Pamet Harbor. Another whaleman declared he was the second. Both affidavits stated that a third man, perhaps from Truro, then wounded the whale, "and they and we soon killed said whale." The dispute concerned who should get how much of the carcass, which had been towed ashore in Truro for butchering.[294]

Ownership of drift whales was contentious. A contemporary jingle, obviously after 1727 when Provincetown was incorporated, stated,

> *Down on East Harbor bar there lays a cow and a calf;*
> *Provincetowners swear they'll have the whole;*
> *Truroers swear they shan't have but half.*[295]

In 1755, Truro voted to call Reverend Caleb Upham to be their minister. On February 10, a meeting was called to hear his reply, but "as many of the inhabitants are called away from the meeting by news of a whale in the Bay, this meeting adjourned to February 11th." At a later meeting, Upham agreed to come, but for more money and twenty cords of wood per year delivered to his door.[296]

An undated quote identified a specific crew of Wellfleet shore whalemen. Based on their dates of birth and death, it is probable that this crew operated in the 1730s. "A number of early Wellfleet men were known as the 'seed corn gang of whalers.' In the group were Hezekiah Doane, Colonel Elisha Doane, Colonel Elisha Cobb, Joseph Higgins, and Captain Winslow Lewis. These men were generally of the same crew."[297] With two colonels and a captain, who rowed?

Court documents reflected at least sixteen whaling boats of six men each were involved in shore whaling during the winter of 1720 at Provincetown. In 1737, Provincetown men killed only two small whales. Some discouraged whalemen considered a change of residence.[298] By 1748, only two or three families remained. In 1755, only three houses were left. By 1775, the decline had ceased but the British navy came and by the close of the Revolution, Provincetown had no population.[299]

While Chatham experienced several losses of population, the remaining whalemen and fishermen were still thirsty. A document from June 23, 1724, requested an additional tavern license.

June 23 1724
Wee Subscribers humbly shew & petition y whereas Elnathan Eldredg Living somewhat Remoate from Inhabitances & near to ye harbor whare all our Vessels both whaler and fisher men Resort & very often have Nesessary bussness at his house Doe humbly petition y hearing might be licienced in full to Entertaine

Tho Atkins
Daniel Seares Selectmen[300]

affidavit before the town clerk, claiming to have struck but lost a humpback, evidently near shore. The iron, with a thick head and short warp, was not marked.[288]

Harwich's most successful whaleman of this period was Benjamin Bangs, known for off-shore whaling. No records indicate that he participated in shore whaling enterprises. Bangs died in 1769.

In November of 1759, a large school of porpoises was discovered. Eighteen boats engaged in pursuit and some three hundred porpoises were driven ashore at Rock Harbor. Seven of the boats were from the north side of Harwich.[289] The large number of boats indicates that whaling was not dormant.

Meanwhile, whaling on the lower Cape also declined. "Ezra Stiles recorded in his diary in 1762 that one Captain Atkins, a Truro man about sixty years old, told him, 'that he had seen as many whales in Cape Cod [Provincetown] harbor at one time as would have made a bridge from the end of the Cape to Truro shore, which is seven miles across and could require two thousand whales.'"[290] This exaggerated recollection must have occurred after 1710. Stiles said that Truro whalemen took seventy to one hundred whales in the bay every season.

In 1716, Moses Paine recorded two instances of trauma for lower Cape whalemen. On November 29, he recorded that "on this day Capt. Joshua Doane, Thomas Petty, George Vickerie, William Ghustan, Joseph Sweat, and Sam Charles were drowned in going from Eastern Harbor [now called Pilgrim Lake in Truro] to Billingsgate." Five days later he recorded that "we went over to the Back Side and Thomas Smith's whaleboat was dashed to pieces by a whale."[291]

In February 1720, interesting whaling initials were registered by Truro Town Clerk John Snow.

For some reason Joshua Atwood's lance, with which he dispatched finback whales, had a three-square head marked WR. Evidently he was afraid that a person finding a whale with WR on it would never associate the initials with Joseph Atwood, so Atwood made sure that there would be no mistake by registering the initials of his lance.[292]

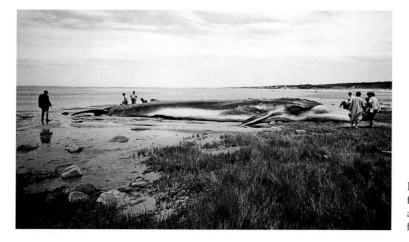

Postcard picture of fifty-six-foot finback ashore on Brewster flats in 1963.

court at Barnstable or Plymouth for the whaling litigations led to attempts to set up a separate county for the lower Cape, or at least establish a court there.

Three attempts were made. In 1723, a court was recommended, but nothing came of it. In 1734, local inhabitants unsuccessfully tried to establish a new county, incorporating Eastham, Harwich, Chatham, Truro and Provincetown. Finally, in 1737, a petition was presented to the General Court requesting that courts be held yearly at Eastham. This request was rejected.[276]

Newspaper and town documents reflect the decline in whaling. Most of Sandwich's records of the time seem to refer to deep-water whaling. In 1739, the *Boston News-Letter* reported that only two small whales were taken at Sandwich.[277]

Barnstable felt the scarcity. In 1720, Thomas Pease, an Indian whale fisherman, was summoned by the constable for failing to pay fifteen other crews their share of a whale caught at Cape Cod [Provincetown]. The document spells out the payment schedule that wasn't followed:

> *Ye sd Defendants doth unjustly refuse or neglect to tender an account of & deliver unto the plaintiffs ye effects of one sixteenth part of a whale fish which was killed by ye plaintiffs & ye defendants & others then mated with them In Cape Codd harbor & sd whale was brought on shore at cape cod within our county of Barnstable & then cutt up & secuered by ye sd plaintf & said defendants & others then mated with them sum time in nouomber in ye year 1720.*[278]

While shore whaling was declining, whaleboats were still valued. When he died in 1721, John Goodspeed of Barnstable had an estate inventory that included "whale-boat and tacklin."[279] The word "tacklin" is different from "craft," and its meaning isn't known. A 1723 agreement by Jonathan Davis to build a whaling vessel for John Gorham showed that boats were still needed. The cost wasn't mentioned.[280] That year, a Barnstable whaleboat was stolen at Martha's Vineyard. The boat was "from Gorum [Gorham] grandson of Lutenant Colonel previously mentioned. Boat stolen from Vinyard January 1723."[281] Peter Gorham is named a whaleman in a 1733 document, indicating that whaling was still important ten years later.[282] An interesting document in 1739 discussed freighting oil to Boston. A charge of five pounds a barrel was charged, but some oil was not merchantable. The total price included, of course, the phrase "Errors Excepted."[283]

In Yarmouth, whaling also declined. In 1716, Jonathan Howes was killed by a whale that he had attacked in a boat.[284] In 1720, Shubell Moses of Yarmouth and Thomas Pease of Barnstable were summoned by the constable. They had not paid other crews their share of a whale. Nathaniel Clark of Yarmouth was one of the grieved persons. The names appear to be those of an Indian crew.[285] Fifteen boats working on one whale indicated a shortage of whales.

In a 1738 *Boston News-Letter* item, it was noted that Yarmouth men had killed but one whale that season through February of that year.[286] The lack of whales continued. In 1754, Selectman John Hallet petitioned the province to excuse Yarmouth from sending a representative to the legislature due to the failure of the whaling business.[287] Jasher Taylor of Yarmouth filed an

DECLINE OF SHORE WHALING AND RISE OF BLACKFISHERIES

After 1715, shore whaling declined, as had drift whaling which had started declining thirty years earlier. "As early as 1681, Andros reported that very few whales were driven on shore unless proved to have been struck by the fishermen. When the shores were well watched and boats patrolled the fishing grounds, there were few stranded whales."[310]

The decline in drift whales indicated that whale stocks were declining.[311] It was only natural that Cape Codders would turn to another oil-producing animal, the blackfish, known today as a pilot whale. Try yards that appear in records after the Civil War were used mostly for blackfish, rather than by original shore whalers.

Men from New England were looking elsewhere for whales. Had whales been plentiful, this would not have been necessary. North Carolina granted whaling privileges "by granting a Power or Liberty to any New England Men or others to catch Whale… paying only two Deer Skins yearly to the Lords as an acknowledgement."[312]

CHRONOLOGY REGARDING WHALING AND BLACKFISHING: 1716 TO PRESENT

August 16, 1716—"On this day there was a great school of blackfish Drove on shore at mr. John Mulford's cleft."[313]

1741—A great number of blackfish and porpoises came into Cape Cod Bay. By the close of October, 150 porpoises and 1,000 blackfish had been killed, yielding about 1,500 barrels of oil.[314]

October 1742—The people of Truro killed nearly four hundred blackfish at Mulford's Cliff, near Truro. They cleared seventy-nine pounds (English currency) per share.[315]

September 1743—Sixty blackfish were captured off Robin's Hill in the north precinct. Proceeds were shared among those involved. Each received twelve pounds.[316]

1744—About three hundred blackfish were killed at Skaket by a few men.[317]

1745—A school of blackfish was discovered off Robin's Hill. Judah Berry's boat crew engaged in pursuit and succeeded in capturing eight.[318]

1747—"Shubael Gorham & Elisha Lumbart give land for a way from Lt. Ebenezer Leyes [Lewis] land to ye old try house & so to ye Shoar at South Sea [try works on south side of Cape].[319]

1754—Selectman John Hallet petitioned the province to excuse Yarmouth from sending a representative to the legislature due to the failure of the whaling business.[320]

1754—Truro voted that "if any person take a boy under ten years old to drive black fish or porpoises, he or they shall have nothing allowed for the boy."[321]

1759—In November, a large school of porpoises was discovered in the bay. Eighteen boats were engaged in pursuit and some three hundred porpoises were driven ashore at Rock Harbor. Seven of the boats were from the north side of Harwich.[322]

1793—Reverend Levi Whitman of Wellfleet recorded he saw four hundred blackfish lying upon the shore of the bay at one time, and full-grown ones would weigh five tons.[323] William Sache, author of *Names of the Land*, states that Blackfish Creek was named for this event.

1793—Levi Whitman wrote, "Blackfish size is from four to five tons weight, when full grown. When they come within our harbors, boats surround them. They are as easily driven to the shore as cattle or sheep are driven on land. The tide leaves them, and they are easily killed. They are a fish of the whale kind, and will average a barrel of oil each. I have seen nearly four hundred at one time lying dead on the shore."[324]

1794—"Ebenezer Taylor of Yarmouth took up a New Whale Boat on Yarmouth Masscts ye 22d of November 1794 & said report to me of ye same. This Carried off on a Little Book for that Purpose. John Thacher, Town Clerk"[325]

1794—"Rev. John Mellen, in an historical sketch published in 1794 noted: 'few whales now come into the bay, and this kind of fishery has for a long time (by this town at least) been given up.'"[326]

1802—"Two or three whales, producing about a hundred barrels of oil, are every year caught in the harbor. Black fish are now seldom obtained."[327]

1828—The *Barnstable Patriot* of November 7, 1828, stated that grampus oil was selling at eighteen dollars a barrel.

1828—A whale rib owned by the Historical Society of Old Yarmouth is inscribed, "rib of whale killed at Yarmouth Port 1828."

1828—Yarmouth town meeting records indicated no whales for distribution. The town voted for no fish committee on March 3, 1828, and March 2, 1829.

1834—"One Sunday late in the fall, when the fishermen were quitting on their way home in boats from Provincetown an immense school of blackfish were discovered… They landed at Great Hollow."[328]

1836—"Another fisherman told me that nineteen years ago [1836] three hundred and eighty were driven ashore in one school at Great Hollow."[329]

1841—"A whale of the right whale species was killed the 25 inst. off the south shore of Edgartown, by some enterprising whalemen of that town. It is said it will make from 40 to 45 barrels of oil."[330]

1843—"May 11, a monster whale was captured near the end of Cape Cod, by Capt. Ebenezer Cook in a small pink-stern schooner of about 50 tons. The whale was estimated at 200 bbls. of oil and about 2000 lbs. of bone. Not having proper facilities for the purpose, only 125 bbls. of oil and about 300 lbs. were saved. The real value of the whale was estimated at $10,000."[331]

1850—The last week of January, a large right whale was captured in Provincetown Harbor. A second was taken a week later. In November of the same year in Provincetown Harbor a right whale damaged a whaleboat and injured the helmsman.[332]

1850—Seventy-five blackfish went ashore between Wellfleet and Truro.

May 13, 1853—The *Yarmouth Register* reported, "Shore Whaling—Capt. Ebenezer Cook and crew recently killed and brought into Provincetown harbor three whales in one week. Several whales have been seen and chased among vessels at anchor in Provincetown this spring."

September 2, 1853—The *Yarmouth Register* printed a letter about blackfish fishing at Provincetown, including a description of the actual driving them to shore. In a separate article was written, "On Saturday morning of last week, Capt. Daniel Rich discovered a large number of black fish, on and near the beach, and succeeded in securing no less than 82 of the number. The fish will yield from 75 to 80 barrels of oil, worth 55–60 cents a gallon."

December 11, 1854—A right whale was harpooned in Provincetown Harbor, but was lost.[333]

December 1854—In the middle of December, a dead right whale with a harpoon in it turned up on Sandwich beach. The whale had been earlier harpooned in Provincetown Harbor.[334]

1854 or '55(?)—"One pleasant summer morning perhaps thirty years ago, Captain Daniel Rich who lived on Bound Brook Island, some distance along the shore, high and dry, he saw some object…Before going to breakfast that morning, he had marked seventy-five monstrous blackfish, that he sold before night for nineteen hundred dollars."[335] (Are these the same blackfish reported in the *Yarmouth Register* and/or that Thoreau saw in 1855?)

July 1, 1855—"A large school of blackfish were discovered in the Bay and driven ashore at Horse Neck, East Brewster and Orleans—They are very large and their oil is valued between $4–5000."[336]

July 20, 1855—"A school of 73 blackfish was driven into Barnstable Harbor by Captains Joshua Hamblin and Jacob Howes. They are unusually large and fat and thought to bring about $1200."[337]

July 1855—Henry David Thoreau watched a large school of blackfish being captured at Great Hollow. Farther north another school was being chased ashore, and 30 blackfish had been killed as he arrived. A few days before, he noted that 180 blackfish were driven ashore at Eastham. The keeper at Billingsgate light went out one morning to find a fortune in fish stranded around his lighthouse. Before anyone else was aware of his good luck, he initialed every blackfish for later sale to Provincetown butchers for a total of $1,000.

From Thoreau:

> *In July 1855, a carpenter who was working at the lighthouse arriving early in the morning remarked that he did not know but he had lost fifty dollars by coming to his work; for as he came along the Bay side he heard them driving a school of blackfish ashore, and he had debated with himself whether he should not go and join them and take his share, but had concluded to come to his work…*
>
> *I could see about a mile south some large black masses on the sand, which I knew must be blackfish, and a man or two about them…I soon came to a large carcass whose head was gone and whose blubber had been stripped off some weeks before; the tide was just beginning to move it, and the stench compelled me to go a long way around. When I came to Great Hollow I found a fisherman and some boys on the watch, and counted about thirty blackfish just killed, with many lance wounds, and the water was more or less bloody around. They were partly on shore and partly in the water, held by a rope round their tails till the tide should leave them. A boat had been somewhat stove by the tail of one.*

...The fisherman slashed one with his jackknife, to show me how thick the blubber was,—about three inches; and as I passed my finger through the cut it was covered thick with oil. The blubber looked like pork, and this man said that when they were trying it the boys would sometimes come round with a piece of bread in one hand, and take a piece of blubber in the other to eat with it, preferring it to pork scraps. He also cut into the flesh beneath, which was firm and red like beef...

They were waiting for the tide to leave these fishes high and dry, that they might strip off the blubber and carry it to their try-works...They get commonly a barrel of oil, worth fifteen or twenty dollars, to a fish. There were many lances and harpoons in the boats—much slenderer instruments than I had expected. An old man came along the beach with a horse and wagon distributing the dinners of the fishermen, which their wives had put up in little pails and jugs, and which he had collected in the Pond Village, and for this service, I suppose, he receive a share of the oil. If one could not tell his own pail, he took the first he came to.

As I stood there they raised the cry of "another school," and we could see their black backs and their blowing about a mile northward, as they went leaping over the sea like horses. Some boats were already in pursuit there, driving them toward the beach. Other fishermen and boys running up began to jump into the boats and push them off from where I stood, and I might have gone too had I chosen. Soon there were twenty-five or thirty boats in pursuit, some large ones under sail, and others rowing with might and main, keeping outside of the school, those nearest to the fishes striking on the sides of their boats and blowing horns to drive them on to the beach. It was an exciting race. If they succeeded in driving them ashore each boat takes one share, and then each man, but if they are compelled to strike them off shore each boat's company take what they strike...

In the meanwhile the fishes had turned and were escaping northward toward Provincetown, only occasionally the back of one being seen. So the nearest crews were compelled to strike them, and we saw several boats soon made fast, each to its fish, which four or five rods ahead, was drawing it like a race-horse straight toward the beach, leaping half out of the water blowing blood and water from its hole, and leaving a streak of foam behind. But they went ashore too far north for us though we could see the fishermen leap out and lance them on the sand...

I learned that a few days before this one hundred and eighty blackfish had been driven ashore in one school at Eastham, a little farther south...

...About a week afterward...walking on the beach was out of the question because of the stench...Their decaying carcasses were now poisoning the air of one county for more than thirty miles.[338]

September 1855—"A school of blackfish 102 in all, were driven ashore at truro last week."[339]

November 30, 1858—The *Inquirer* reported that a right whale was seen in Provincetown Harbor. A harpoon gun was fired at it but the whale escaped.[340]

1865—Blackfish were killed at Provincetown.[341] Note: from this point forward, several references allude to strandings and citations are not always given.

1870—767 blackfish came ashore on Cape Cod, yielding 1,020 barrels of oil.

1873—A six-foot sperm whale washed up dead on Billingsgate Island.[342]

1873—Oil works were built next to the lighthouse in Wellfleet. The first year, blackfish were tried out by the old process. Steam works were then added, improving the yield. They had machinery to further refine oil to be used with watches.[343]

1874—"In 1874 a company was organized [in Wellfleet] under the name of the North American Oil Company, for the purpose of trying out blackfish blubber. Its capital, invested in a building, a steam-boiler, tanks, kettles, boats, etc., amounts to $2400. In 1875 the number of barrels of oil extracted was 300; in 1876, 100 barrels. During the years 1877, 1878, and 1879 no blackfish appeared on the coast, and the company was obliged to suspend operations."[344]

1874—The largest school of blackfish ever known to be driven ashore at Cape Cod (1,405 total) came up on the Truro beach, yielding 27,000 gallons of oil. They lay on the shore from Great Hollow to Pond Landing, a distance of a mile. This stranding is often shown on postcards, which mistakenly state that it was in 1884.

November 11, 1874—Heman Dill, lightkeeper at Billingsgate Light, wrote in his journal, "A grate Cry of Blackfish. All hands turned out and Drove on Shore about 3 hundred at

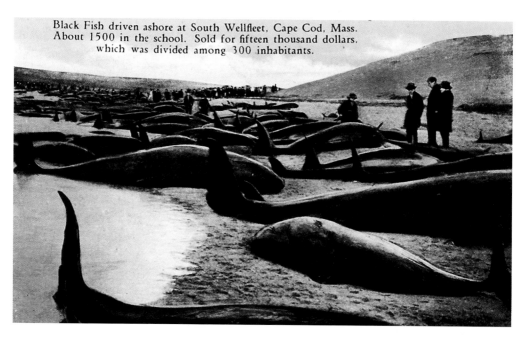

Black Fish driven ashore at South Wellfleet, Cape Cod, Mass. About 1500 in the school. Sold for fifteen thousand dollars, which was divided among 300 inhabitants.

Postcard picture of 1874 beaching of fifteen hundred blackfish at Wellfleet. The whales were worth $15,000, divided among three hundred people.

Truro." Two weeks later his journal included, "Drove on Shore at the Island 66 Blackfish. Also 175 at Eastham the Same Day—About 3 hundred people at the Sean [scene]."[345]

July 1875—In North Dennis, 120 blackfish beached themselves. (Note: this and the following description may be the same stranding.) Kittredge, in *Mooncussers of Cape Cod*, mentioned that they came ashore in Orleans and that Captain Ben Gould drowned trying to get to them.

August 1875—119 blackfish were driven ashore in Dennis; 80 were females.[346]

September 1878—A school of blackfish hovered around the entrance to Provincetown Harbor, fleeing two large whales with high back-fins.

1879—Five-year-old Thornton Burgess went to Town Beach in Sandwich to watch a striped whale being cut up by a Provincetown whaleman. This was in TWB's autobiography.

1880—The year 1880 marked a revival of shore whaling in Massachusetts waters, and for some fifteen years much profit was had from the capture of finbacks and humpbacks. Most whaling was carried on from Provincetown and the weapon of choice was a bomb-lance fired from a shoulder gun. In March, thirty-eight whales were brought in and landed at Jonathan Cook's oil works at Long Point. Early in June, ten whales were killed

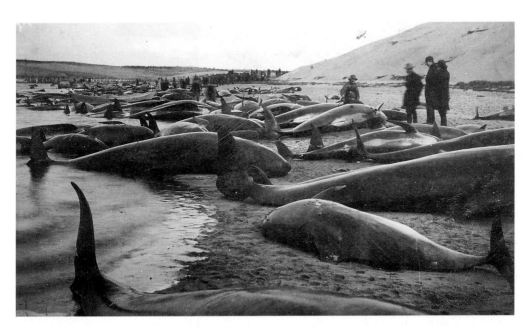

Photo of fifteen hundred blackfish ashore at Wellfleet in 1874. The picture erroneously states the date as 1884. This photo was used for postcard pictures and in an ad for Nye's watch oil. *Photo courtesy of Historical Society of Old Yarmouth.*

and landed at Cook's oil works, with an average price of $0.40 a gallon. They yielded 950 barrels of oil, worth $14,037.50.[347]

1880—An oil factory existed at West End, according to the 1880 *Atlas of Barnstable County*. The oil factory was located next to Central Wharf.

1881—In the spring, fifteen whales were killed, yielding three hundred barrels of oil. There was then a four-year lull in whaling.[348]

1881—"Ships in Provincetown sometimes delayed their departure for distant whaling grounds in order to hunt whales in Cape Cod Bay…Once in 1881, twenty whales were harvested in this fashion in a single day".[349] Whether the fifteen whales mentioned previously are included in this count is uncertain.

1884—The value of a stranded blackfish on Cape Cod varied from five dollars to forty dollars.[350]

November 17, 1884—This date was often mistakenly reported on postcards for the largest stranding ever of blackfish. It should have been 1874.

November 1885—Twelve hundred to fourteen hundred blackfish, worth about $12,000, were driven ashore from Provincetown to Dennis. During the last days of December, five to six hundred blackfish came ashore on the backside of Sandy Neck.[351]

1885—Fifteen hundred blackfish entered Wellfleet Bay and were driven into Blackfish Creek. "Hundreds of men in boats surrounded the school, and frightened them into the narrow and shallow waters of the creek, where they were left on the beach by the receding tide. They were sold for $14,000 and the money was divided among those who assisted in the capture and killing."[352]

? ... !SH.

MONSTER ' ... ORS F ... THE BRINY DEEP.

Provincetown, Truro and Wellfleet,

The capture of fifteen hundred of these fish at Black-fish Creek, South Wellfleet, Nov. 17th, 1884, by the people of Provincetown. Truro and Wellfleet, was one of the most exciting scenes in the annals of the coast fishery.

These fish were attracted to our shores by the large quantity of squid and herring on which they feed. They are very valuable for the fine oil they make for use on watches and other delicate machinery.

It is estimated that the number captured were worth about $25,000. Some of them weighing two tons apiece.

(Copyright secured.)

Write-up on rear of 1874 photo. *Historical Society of Old Yarmouth archives.*

1885—Finbacks appeared in large numbers on the coast.[353]

1885—"After 1884, [Captain Stull, the writer of the quote, may mean 1885] pilot whales apparently became frightened by the repeated raids made upon them by the whalers, and not one was seen near the Cape for almost thirty years. Thinking that they had become extinct, most of the fishermen sold their apparatus to curio seekers; but in 1912 in July, thirty came ashore near Wellfleet.

"A second school of fifty became stranded a few weeks later. Within a few days, still another collection, which numbered one hundred and eighty, was brought up on the beach by a high course tide. Practically all of them were abandoned, owing principally to the lack of apparatus with which to prepare the fish. This meant a loss of at least $10,000, for each fish produces a barrel of oil, which can be sold for approximately 40 cents per gallon, outside of the head oil."[354]

1886—An oil works was constructed near Race Point Light. In 1887, a bone crusher was added to reduce whalebones to lime. The year was less productive than 1885.[355]

1887—Job Cook had fourteen whales at one time at his oil works on Long Point.[356]

1895—Eleven whales were taken up to May 10. Captain Nickerson had an oil works at Herring Cove, where he processed eight whales in 1895.[357]

1896—This year practically closed finback whaling in Cape waters. Try works had fallen in disuse; there was an occasional whale in Provincetown Harbor, but no attempt to capture it. Oil prices were way down; by 1903 all whaling was gone.[358]

1907—Nineteen blackfish came ashore on Monument Beach in Bourne. They sold for nineteen dollars apiece.

1910—Blackfish came ashore at Wellfleet.

July 1912—Thirty blackfish came ashore near Wellfleet. A second school of 50 became stranded a few weeks later. Within a few days, still another collection, which numbered 180, was brought upon the beach by a high course tide.[359]

1914—"Two summers ago [1914; Stull was reporting this in 1916], an even hundred stranded at Eastham. The largest was 22 feet in length while a tiny one stretched exactly 3 feet."[360]

1916—Five hundred blackfish came ashore on Cape Cod.

August 3, 1918—A school of 128 blackfish stranded on Cliff Bathing Beach in Nantucket. Steaks were cut from them and served in some of Nantucket's hotels.

Photo of 1889 whaleboat in Yarmouth's 250th anniversary parade. The "whaleboat" is actually a fishing dory. *Historical Society of Old Yarmouth archives.*

Close-up of Wellfleet 1910 picture. *Courtesy of Sturgis Library, Barnstable, Massachusetts.*

1918—An eighty-seven-foot dead sperm whale drifted in the bay and grounded in Wellfleet.[361]

November 9, 1918—There were five hundred blackfish at Provincetown, and ninety ran aground.[362]

1926—Five hundred blackfish came ashore on Cape Cod.

1928—A dead finback in Barnstable Harbor finally landed on the back side of Great Island in Wellfleet.[363]

1930s—Author Phil Schwind wrote about two strandings during this decade. His article appeared in the *Cape Cod Times* on December 15, 1986.

1933—In the winter, a finback whale came ashore at Monomy point.[364]

1936—In the winter of 1936–37, there was a sixty-foot sulphur bottom on a tidal flat of West Dennis.[365]

1940s—For three consecutive years during World War II, there were pilot whale beachings in Eastham. Inhabitants took the head oil. One photograph showed the Bresnahan family of Massasoit Road in North Eastham at First Encounter Beach in the fall of the early 1940s.[366]

1959—A live sixty-foot finback came ashore at Provincetown. It died and was towed out to sea.[367]

December 4, 1975—The *Yarmouth Register* showed several pictures of a beached whale. Most probably the whale was a finback.

1981—Eighteen pilot whales came ashore on Cape Cod.

1982—Ninety pilot whales came ashore on Cape Cod; fifty-nine beached in Wellfleet in November (some say sixty-five beached themselves).

1983—Twenty-three pilot whales came ashore on Cape Cod.

1986—Two hundred pilot whales washed upon the shores of Eastham; some say there were only sixty at Eastham, and seventy total for the year.

1990—Fifty-three pilot whales came ashore on Cape Cod; another report says fifty-five were beached at Hyannisport.

December 3, 1991—Ninety-six pilot whales came ashore at Boat Meadow Creek in Eastham.

December 24, 1991—Thirty-one pilot whales came ashore.

December 23, 1992—Nineteen pilot whales came ashore at Pamet River, Truro.

2000—Fifty-four pilot whales stranded on Square Island in Hyannisport; also ten beached themselves in July on Capuam Beach, Nantucket.

November 8, 2001—There was a blackfish stranding.

July 29, 2002—Fifty-five pilot whales beached themselves on Chapin Beach, Dennis; after forty-six successfully refloated, one stranded at Grays Beach at Bass Hole, two on Sandy Neck and one in the Sandwich marsh. On July 30, the remainder beached at Wellfleet; all died or were euthanized.

These are citations found during the authors' research. Many of these twentieth-century facts were derived from the *Boston Globe* July 31, 2002, and the *Cape Cod Times*, July 30 and August 1, 2002.

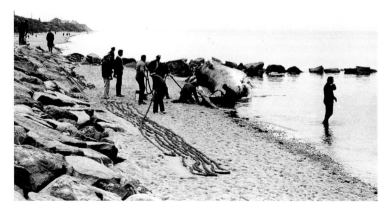

1975 picture of finback tied to shore. Line is laid out in sand. *Historical Society of Old Yarmouth archives.*

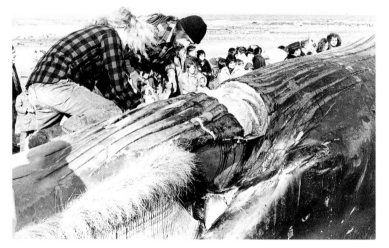

Picture of December 1975 finback ashore. Note the thickness of the blubber and the baleen. *Historical Society of Old Yarmouth archives.*

Postcard picture of white-sided dolphin at Herring River in Wellfleet.

INDIANS AND SHORE WHALING

There exist two accounts of Indians whaling prior to the arrival of the European settlers. In 1590, Joseph de Acosta wrote that Indians paddled up to a sleeping whale and drove wooden stakes in each of its nostrils to kill it. This report is generally discounted, and even ridiculed.[368] A more credible account by Captain George Waymouth in 1605 stated that he watched Indians harvesting a live whale. Waymouth reflected, "They divide the spoil...and when they boil them, they blow off the fat, and put their pease, maize, and other pulse which they eat."[369] They didn't use the oil, but used the whale for food.

Whether Indians taught the new settlers or they learned from the colonists is a question that must be addressed if one is to understand the origins of North American shore whaling. Authors who have researched Indian whalers agree that New England Indians didn't do much actual whaling. Elizabeth Little reflected on her research:

> In spite of tradition, I can find no evidence that Indians of New England routinely killed whales at sea, or used anything resembling a drogue, until the introduction of European whaling technology to the colonies. The credit given by early whaling historians to the American Indians was apparently earned by their remarkable seamanship and innovative use of European technology.[370]

Edouard Stackpole concurred. "Although the Indian probably taught the white settlers the art of harassing a stranded whale, it does not follow that his primitive methods were used thereafter...Perhaps the Indians' greatest contribution, following their first instructions to the settlers in driving ashore or killing a stranded whale, was in their capacity as whalemen."[371]

There is a report of a colonist witnessing Indians whaling. "As far back as 1642 Thomas Mayhew Jr. and his companions had observed the Indian doing his off-Nantucket shore whaling in fragile canoes."[372] Indians of the area mostly used dugout canoes, and they were far from fragile looking. Whether this observed act was actually

Indian indenture for whaling. *Historical Society of Old Yarmouth archives.*

whaling or traveling to Martha's Vineyard isn't certain. There are no other citations to back up this observation.

Indians used whales for food and gifts. They had no effective way of trying oil from blubber, lacking the large iron try pots used by European settlers. Among the Montauk Indians the tail or fin of the whale was the most savory sacrifice to their deity.[373] Roger Williams of Rhode Island reported, "In some places the whales are often cast up…The natives cut them into several parcels and give and send them far and near, for an acceptable present or dish."[374]

An Indian deed in 1679 allowed Indian Job Notantics to have liberty to cut the fins and tails of whales cast ashore on the neck at Falmouth.[375] Indians on Nantucket and Martha's Vineyard felt "Moshup, their legendary whaleman, was kind to them, by sending whales, etc. ashore to them to eat."[376]

Indians were sometimes given the "lean" of whales that had been killed for oil. In the notes regarding the resolve to let Thomas Houghton of Boston take whaling remains to make saltpeter, one use for the lean was crossed out. It stated that the lean was "for Indians and swine to eat."[377]

Indians retained rights to drift whales, but often deeded "drift whale rights to English along with land at Martha's Vineyard and at Long Island…Martha's Vineyard Indians reserved a few…Nauset Indians reserved part of the blubber of whales that should be driven ashore."[378] On Nantucket, "all the whal fish or other Drift fish belong to the Indian sachems" was written in Nantucket County Deeds 2 (b:4). Indian ownership of drift whales at Martha's Vineyard and Long Island was also recognized.[379] "The

Vineyarders took whales several years before Nantucket was settled…One Indian sachem in selling his land reserved the right to 'four spans around the middle of every whale that comes upon the shore.'…proprietors transferred rights 'of fish and whale' with their deeds to land."[380]

Eastham made a compact with Indians in 1697 that allowed Indians one-eighth of all drift whales on both shores.[381]

The Indians who lived on Cape Cod and the islands were experiencing a severe period of decline. A plague in 1617 decimated their population, although the Nausets were not severely affected.[382] On Nantucket, a precipitous decline in Indian population occurred, from 2,500 in 1600 to 1,250 by the year 1670, to 136 by 1764.[383] In only 164 years, Nantucket's Indian population declined by 95 percent.

There were 1,500 Indians on Martha's Vineyard in 1642; by 1720, only 800 remained.[384] Of these 800, 110 were debtors to tavern keeper Robert Cathcart.[385] It is noteworthy that their indebtedness was to a tavern keeper, indicating alcohol was a major cause of Indian debt and indenture.

In 1674, 264 Christianized Indians lived in Eastham, including the Pamet, Billingsgate and Nauset areas. This number does not reflect the total number of Indians, but rather only those Christianized.[386] According to Reverend Treat, there were only 500 Indians east of Yarmouth in 1693.[387]

A plague/pestilence struck Indians in the Chatham area in 1730. Those that died included Zachariah, Jonathan Tom, Jeremiah Quansett and Stephen alias Mortiquit. "It should be remembered of these Indians that they were good whalers and good soldiers."[388]

There were few Indians remaining in Eastham by 1745. By 1764, only four resided there, eleven in Wellfleet and ninety-one in Harwich.[389] Indians east of Yarmouth on Cape Cod gradually moved to Indian Town in Yarmouth, near the present Bass River Bridge on Route 28. Smallpox ravaged them and soon after the American Revolution, they too were gone. Many Indians on the Cape and islands died of disease or "simply disappeared into the rich genetic soup that made up the underclass on Cape Cod and the Islands."[390] Two censuses of Indians in Massachusetts, in 1848 and 1859, showed a great deal of intermarriage with both blacks and whites.

Whether Indians were treated fairly by colonists is disputed. The numbers of Indians on early whaling designs is pointed to as evidence of some good feeling between Indians and colonists. Michel Crèvecoeur noted that as late as the mid-1700s most English islanders [Nantucket] were able to speak a rough form of the native language.

Author Elizabeth Little is one who believed relations were not that poor. "On the whole, I think the first half of the eighteenth century on Nantucket was an excellent time to have lived there, and that English/Indian relations, while certainly not perfect, have to be considered among the best in America."[391] Glover Allen, another respected author, stated that the Nantucket Indians were treated with consideration from the beginning.[392]

Others felt less consideration was given to the Indians. Author Daniel Vickers is one of these. "The white Nantucketers who launched the shore fishery in the 1690's were certain about two things. First, though they agreed to participate in the actual chase

as steersmen or harpooners, they refused the menial labor of manning the oars…The second point on which the English insisted was that they retain complete control of the industry themselves."[393]

The Indian way of life contributed to this problem. The real barrier to native investment in shore whaling was the Indians' reputation for unreliability.[394] "In the Nantucket shore fishery class and race were contiguous. The English were masters; the Indians were servants, and between the two there was no mobility at all."[395] The indenture system is blamed for much of the problem, as exemplified by the following paraphrasing from historian Daniel Vickers's research. Vickers suggested that the vast majority of Native American whalers were little more than slaves, assigned by English courts to specific captains for years on end as punishment for relatively minor infractions.

Debt was the most common way to become indentured. Vickers estimated that three-quarters of the native whalers between 1725 and 1733 were debt slaves. Rights to Indian debt labor could be sold, and the court occasionally held auctions in which there wasn't an obvious plaintiff. Native laborers were handed down from generation to generation, virtually always along with the owner's whaling gear.

Indenture was so one-sided that in 1716, John Punker, a Nantucket Indian, appealed to the Massachusetts Legislature to provide an off-island court where Nantucket Indians might obtain justice. A committee of three investigated, and to its credit the colonial government ordered that off-island judges be appointed to hear all matters relating to Indians. The preamble to the resulting legislation said,

> *A great wrong and injury happens to said Indians, natives of this country. Drawn in by small gifts, or for small debts, when they are in drink, and out of capacity for trade, to sign unreasonable bills or bonds for debts, which are soon sued, and great charge brought upon them…they have no way to pay the same but by servitude…with the rise of deep-sea fishing after 1716, the competition for available* [Indian] *hands grew even more acute…Coercion became so routine in the economic process that by the 1720s the General Court was flooded with Indian complaints of indebtedness and ill treatment.*[396]

Judging from the number of complaints that came into the General Court, the 1718 effort to reform the Indian indenture system failed. By the time the legislature again addressed the issue in 1725, the whaling interests were strong enough to win an exemption from the prohibition on indentured Indian householders. Under the new law for the Cape and islands, Indian servitude was regularized at two-year intervals, with employers supposedly helping to provide housing for the workforce. Furthermore, just in case someone had the idea of working off his debts, Indians were required to buy all supplies from the company store of whoever owned their initial debts.

As Vickers summed up, "Fraud had been prohibited, but servitude was now institutionalized…the first bloom of the whaling industry employed virtually all of the male Indians in coastal Massachusetts."[397]

Indians who had to "find themselves" while indentured meant they had to provide their own provisions and housing. Such was the case of Indian Jacob Zachariah in his

indenture to Ebenezer Hallet in 1718/19. An unanswered question about this document is why an Indian from Dukes County would be indentured to a Yarmouth citizen from Barnstable County.

Although their numbers steadily declined after the arrival of the Pilgrims, colonists knew the important part Indians played in this trade. Indian labor became even more important as whalers went farther from land in pursuit of whales.

The extension of credit to Indians for consumables such as alcohol ensured that Indians would continually be in debt. The probate records of the early settlers of Cape Cod show large amounts of money owed them by the Indians. Indenture was a way to recoup these debts. In 1720, a Vineyard tavern keeper had 110 Indians as debtors. Alcohol remained an important source of native indebtedness to the end of the colonial period.[398]

The big difference between being a slave or indentured was that indentured servants had rights and their term of service was for a fixed period of time. Sometimes, however, the distinction blurred. Slavery was common on Cape Cod until after the American Revolution, "and if there were fewer on the Cape than elsewhere, it was only because there were fewer rich men or extensive land-owners."[399]

Black slaves were known to be part of the whaling designs, and free blacks also participated. They too were held to be inferior. "Indians, like blacks, were praiseworthy, but only as long as they acted with deference."[400]

The leader of the Howes (Dennis) whaling crew was a black man named Hezekiah Neagur, who was affectionately called "Old Kiah." There is no question of his status—he was a slave—but he had earned the respect of the family for which he labored. He had been allowed to marry, taking for his wife an Indian woman named Deborah…they had seven children…The men who made up the crew of the whaleboats which Hezekiah headed were mostly Indians. They were classified as servants, not slaves, and were paid for their labor. Other men in the neighborhood joined the whaleboat crews in the chase.[401]

Quaker historian Laurence Barber asserted that no known Quakers on Cape Cod owned slaves.[402]

African Americans commingled extensively with the declining and equally marginalized—though still much larger—native population. Curfews for blacks and Indians became a method of control. Some historians have made an issue of Nantucket's action in 1723. In that year, the town of Nantucket set a curfew for "Indians, Negroes, and other suspected persons…If they shall be found upon the wharf and about town after nine of the clock at night, they shall be taken up and carried before a justice."[403] In fact, a 1703 law enacted by the Massachusetts General Court twenty years before Nantucket's stated, "No Indian, negro or mulatto servant, or slave may presume to be absent from families whereto they respectively belong, or be found abroad in the nighttime, after nine o'clock."[404]

Injustices continued after shore whaling declined. In the nineteenth century, the town of Yarmouth voted at its March 6, 1826 town meeting to require Indians and

"coloureds" to move the graves of their ancestors from a place near white citizens in the Ancient Cemetery to a distant spot in the southeast corner of the cemetery.[405]

The history of Indian relations from early settlement until now has been hurtful and unfortunate.

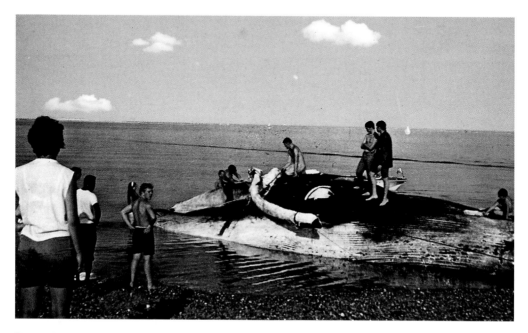

Postcard picture of removing jawbone of sixty-three-foot finback. The jawbones now enhance the entrance to the grounds at the Captain Penniman house in Eastham.

Jacobus Loper and Ichabod Paddock

Jacobus (James) Loper

James Loper was closely associated with the beginnings of shore whaling, but mystery surrounds him. His father, Lieutenant Captain Jacob Loper, was born in Stockholm, Sweden, February 25, 1616/17. Sailing from Sweden in the service of the Dutch West Indies Company, he settled in New Amsterdam before 1642. Jacob is referred to as Jacob Lugt de Loper, a Swedish ship's captain. In one Loper genealogy, he is the commander of a Dutch warship. From 1643 to 1646 he captained a vessel sailing to and from Curacao, West Indies.[406] Loper married Cornelia Melyn on June 30, 1647, in New Amsterdam. They had two children: James Jacobus Loper, born before 1648; and Jannekin (Johanna) Loper, born in June 1650.

There is nothing that indicates that Jacobus Loper (the father) was involved with whaling. Shortly after he was refused a license to trade by the New Amsterdam authorities, he reportedly died.[407] His death occurred between 1651 and 1653, because in 1653, his wife Cornelia married Jacob Sckellinger.

Jacobus Loper's son James was involved in whaling. He married Elizabeth Howell in 1674 when she was seventeen. As this was not a happy marriage, she petitioned for divorce on July 15, 1685. Some genealogists state that the divorce was never finalized because James died in April of 1686. However, several events involving a James or Jacobus Loper take place after this date, so reports of his death in 1686 cannot be correct.

James was not always admirable, but he was enterprising and capable.[408] He was involved in whaling as early as 1668, and between that date and 1685 he was frequently mentioned in East Hampton, New York records. Many of these citations involve whaling. A 1675 petition to employ Indians was sent from "Jacob Skallenger, Stephen Hand, James Loper and others adjoined with them in the Whale Design at Easthampton."[409] The son had teamed with his mother's second husband, Jacob Schellinger (a name misspelled in the petition) in a partnership that became a very successful New York whaling operation. They employed many Indians.[410]

The first mention of a Loper coming to New England occurred in 1672. James Loper was invited, along with John Salvidge [Savage], a cooper, to come to Nantucket to teach whaling. Their contract was for three years. No historians today believe that Loper traveled to Nantucket. In 1672, the time of Nantucket's request, James would have been only twenty-four. Perhaps he didn't go because he was interested in Elizabeth Howell, then a girl of fifteen, whom he married two years later.[411] It may have been the wording of the contract ("in all the seasons thereof, beginning the first of March next") that kept Loper away. He would have begun just as the whaling season was ending, and might have little to show for his efforts until the following November or December. A year-round contract for seasonal work might have been the result of lack of knowledge by those in Nantucket, but this is only conjecture.

There is a definite record of a Loper coming to Cape Cod about 1680.

> *An old man Came from Long Island one Loper a Duchman that had been Used to Whaling att Long Island—Came to Barnstable and the Cape Codd* [the Provincetown area]*—or Barnstable Was then abounded In Whales and my Grandfather first fixt out with old Loper awhaling In ye Year about 1680—Old Loper was accounted a Sort of a Wizard.*[412]

The two key words, "old" and "wizard," raise the question of which Loper actually came to Barnstable. In 1680, James would have been thirty-two, hardly old in any traditional sense. His father would have been sixty-four, if he was still alive. Could it have been that Jacobus Loper, James's father, "disappeared" rather than died, and later showed up in Barnstable? There were serious Indian troubles on Long Island, and he could have taken advantage of the turmoil to disappear. The term "wizard" is harder to define, as the *Wast Book* was written when the Salem witch trials were still remembered. Still, a person of thirty-two years old doesn't easily fit the descriptions of old or wizard.

If Jacobus Loper (father) simply disappeared in 1653, rather than dying, he would have fit the *Wast Book* writings of Gorham almost perfectly. However, he would have been too old for other citings on record. Jacobus and James are names used interchangeably. The name Jacobus can become James in English, and this causes confusion as to which James Loper is the actual whaler.[413]

The Loper in question returned to Long Island after his visit to Barnstable. He is listed on the roles of inhabitants for the year 1683.[414] Perhaps his desire to return to Cape Cod caused his wife to consider divorce. He did return to Cape Cod, for in 1686, the constable of Eastham was ordered to attach Jacobus Loper to find sureties for good behavior and appearance at the next court. "Jacobus Loper and Lidia Young, having been presented by the Grand Jury (at June Court Last) for unwell carriages to & with each other—Loper himself on tryall by a petty jury, who found him not guilty."[415] Loper was acquitted of the charge. The name Jacobus was used, not James. At that time James (son) would have been thirty-eight, the father seventy.

In 1688, a petition was submitted to Massachusetts by Jacobus Loper.

The petitioner for 22 years had been engaged in Killing Whales and trying out oyll. He had met with reverses. He now petitions to continue whaling by the use of his invention which he had invented and would not explain to anybody. He asks for a patent for 12 years to whales south of a west line from Pamet River Cape Cod.[416]

Killing whales for twenty-two years would have meant 1666, a time that corresponds with when James (son) started whaling on Long Island.

James Loper was mentioned in another incident on Cape Cod. "In 1689 Loper was captain and owner of a sloop which picked up the pirate, Thomas Hawkins, on Cape Cod and took him to the authorities in Boston. In his deposition, Loper calls himself 'aged 40 years,' which would be right for the East Hampton Loper."[417]

If this person was James the son, his reported death date in 1686 by some Loper genealogists is false. Some assume that his wife didn't divorce him because he died instead. More likely, she reconciled with him some time after he was found innocent of "unwell carriages" with Lidia Young of Eastham.

His wife moved to Massachusetts to be with him before 1688. The *East Hampton Star* reported, "Loper's wife took him back. They were living with James' uncle, Jacob Melyn in Boston in 1686 [actual date 1688] when a daughter Joanna was born."[418] Their daughter Joanna was born to James Loper and Elizabeth Loper on February 6, 1688, and is listed in the Boston Vital Records.[419]

James Loper died in 1691, but is not listed in the Boston Vital Records. This assumption is made because his letter of administration was filed by the Suffolk County Probate Records in Massachusetts and signed by Elizabeth Loper and James's uncle, Jacob Melyn.

There are other less reliable sightings of a Loper in Massachusetts. James Loper is said to be from the Vineyard, according to author George Dow's book *Whale Ships and Whaling*. He does not substantiate why he placed Loper on Martha's Vineyard. Another author, Earle G. Rich, wrote in "A Tavern in the Town," an article for *The Owl* on August 24, 1972, "It is recorded history one Wellfleet oysterman was delivering his product to the markets at the turn of the 17th century. He was Jacobus Loper." Again, no source for this information is cited.

Initially, the authors believed that the father, Jacobus Loper, visited Barnstable. However, after studying all of the information, we conclude that the son, James Loper, sometimes called Jacobus, was the person who came to Barnstable. The son, not the father, is the person involved with whaling in Massachusetts and Cape Cod.

ICHABOD PADDOCK

Ichabod Paddock is the best known Cape Cod whaleman of the seventeenth century. Paddock was born February 2, 1662. His father, Zachariah, born in Plymouth on March 20, 1635/36, died in 1726/27 in Yarmouth. Ichabod's mother, Deborah Sears, was born in 1639 in Plymouth. She married Zachariah on May 1, 1659, and died in 1732.

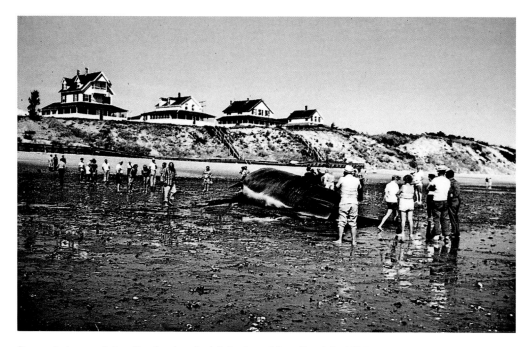

Postcard picture of sixty-five-foot beached finback on Mayo Beach in 1966.

The Paddocks lived in the Nobscusset area of Yarmouth, now Dennis. Unfortunately, several authors have identified Ichabod only from "Cape Cod"—the name used for Provincetown before it was incorporated in the eighteenth century.

Paddock surely came in contact with James Loper when Loper came to Barnstable in 1680. Barnstable men were shore whaling on Sandy Neck while Yarmouth men spent their time at the Black Earth whaling grounds, a mile to the east. Paddock learned the whaling boats' secrets from Loper; in any case he was asked by Nantucket to come to their island in 1690 to teach them how to whale from boats.

Some genealogies identify Paddock's wife as Joanna Faunce, born about 1665 in Yarmouth. She is made famous in myths about Ichabod for fashioning a harping iron out of silver so that Crook Jaw, the whale in league with the devil, could be killed. Others say Ichabod married Elizabeth Brown August 16, 1707, and this seems more probable. Another Ichabod Paddock hails from Yarmouth and this Ichabod may well be the husband of Joanna Faunce. The myth writers chose the wrong woman.

Paddock's two younger brothers went to Nantucket as well, perhaps with him. Ichabod's second brother Nathaniel, born in 1677, was married on Nantucket in 1706.

Some authors give Paddock credit for setting up the entire whaling operation on Nantucket.

Ichabod Paddock soon saw that many more whales frequented the south [shore of Nantucket] than the North shore of the island, and he promptly divided the shore into four "beats," or districts, each about 3½ miles long, built a hut for shelter, and erected a

tall spar, with a "crows nest," at the center of each district. He assigned six men to each boat, one of whom was expected to occupy the lookout perch on the spar at all times.[420]

Respected author Elizabeth Little credits Paddock as being Nantucket's teacher.

Paddock did not spend the rest of his life on Nantucket. By 1710, he had returned to Yarmouth, and was granted seven and a half acres of common land.[421] Yarmouth proprietors records indicate he received additional land on June 1, 1713, in the second division of land and again in the third division of land on July 12, 1714. These were part of the 77th lot and the 130th lot, for which turpentine money was paid.

Ichabod may have returned to Yarmouth because he was disowned by the Nantucket Quakers. "Ichabod Paddock and Latham Gardner were disowned for sailing about the harbor in a vessel where dancing was performed, and keeping company with young women 'not of our society.'"[422] This behavior could have played a part in why myths grew about Paddock being overly friendly with a mermaid.

Ichabod Paddock died in Yarmouth on July 17, 1748.

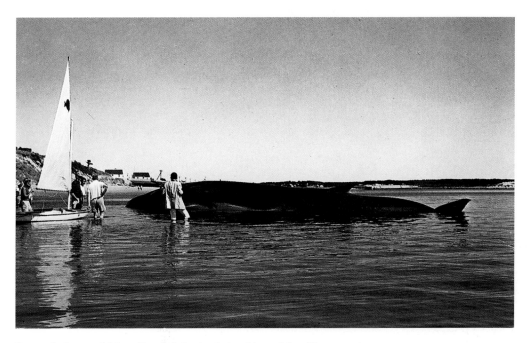

Postcard picture of Mayo Beach finback whale with sunfish sailboat nearby.

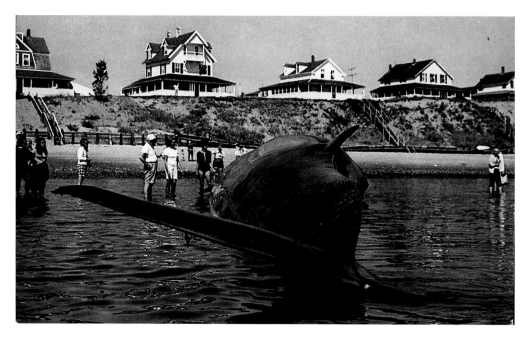

Close-up postcard picture of finback at Mayo Beach.

NOTES

INTRODUCTION

1. Allen, *Whalebone Whales*, 154.

2. Baylies, *Historical Memoir*, Part II, 284.

3. Hawes, *Whaling*, 70.

4. Langdon, *Everyday Things*, 216.

5. Ashley, *Yankee Whaler*, 29. Author Randall Reves wrote about Cape shore whaling, "Shorewhaling may have begun at Cape Cod, Mass. In the 1620s or 30s."

6. Scoresby, *An Account of the Artic Regions*, vol. 2, 11.

7. Whether to capitalize the first letter of whale names is difficult. The authors have followed Alexander Starbuck, early dean of whaling writers, who chose not to capitalize.

8. The authors use the term "whalemen" rather than whaler, as this is most used by those who engaged in the business during the period in question.

9. Kurlansky, *Basque History*, 120.

10. Gosnold named Cape Cod while searching for sassafras. The prime ingredient in the European treatment of syphilis, it was called French pox in England and Spain and Spanish pox by the French.

11. Flayderman, *Scrimshaw*, 15.

12. *Mourt's Relation*, Massachusetts Historical Society Collections, vol. 8, 204.

13. King, *Cape Cod*, 205.

14. Stackpole, *Sea Hunters*, 16.

15. Winthrop, *History of New England*, 157.

16. *Mourt's Relation*, 30.

17. Winthrop, *History of New England*, vol. 1, 157. During the 1640s, ownership of the tideflats was given to property owners to stimulate economic development through the building of wharves and docks. Public rights to use this land were limited to fishing (including whaling), fowling and navigation.

18. *The New England Historical and Genealogical Register* 123/81, no. 2 (April 1969).

19. Church, *Whale Ships*, 14.

20. Simpson and Simpson, *Whaling on the North Carolina Coast*, 6.

21. Kurlansky, *Cod*, 68–69.

22. Lytle, *Harpoons*, 12.

23 McCordle, *Early Printed Maps*.

24. Ibid., 40.

25. Ibid., 71.

Whales: Objects of the Search

26. Allen, *Whalebone Whales*, 171. This was only healthy right whales. A lean right whale sank after being killed off Nantucket in 1886. It rose to the surface forty-eight hours later.

27. True, *Whalebone Whales*, 249.

28. Scientific names come from the website www.physics.helsinki.fi/whale/iwc/reg1946/sefd.html.

29. Peleg Folger's journal.

30. Allen, *Whalebone Whales*, 125.

31. Goode, *Fisheries*, 30, 31. Some still believe that it was a now extinct Atlantic blue whale.

32. Little, "Indian Contribution," quoting a whaleman named Peleg Folger in 1753, 11.

33. Goode, *Fisheries*, 26.

34. Little, "Indian Contribution," 11.

35. Allen, *Whalebone Whales*, 195.

36. Right whales use Cape Cod Bay as winter feeding grounds, starting in December. In spring, they move to Great South Channel, to the southwest of Georges Bank. From June into the fall, they take up residence in the Bay of Fundy for summer feeding grounds. Right whales have been protected from hunting under international law since 1935.

37. Echeverria, *History of Billingsgate*, 94–95.

38. Train oil is a corruption of the word "tran," from the German word tranen, meaning tears. In Dutch it was "traan" or "trayn." This referenced the oil dripping from the blubber, or from the liver of the cod. Cod liver oil was first made by letting the cod livers rot with oil dripping from them. (No wonder cod liver oil always seemed to smell and taste so bad!) Jensen, *The Cod*, 57.

39. Dow, *Whale Ships*, 8.

40. Ibid.

41. Starbuck, *History of the American Whale Fishery*, 26. Cornbury was an interesting character. A complaint was made by Lewis Morris against Governor Cornbury on February 9, 1707, to the secretary of state in London accusing Cornbury of "dressing publickly in woman's cloaths every day." O'Callaghan, ed., *Colonial History of New York*, vol. 5, 38.

42. Reves, Breiwick and Mitchell, "History of Whaling and Estimated Kill of Right Whales," 28.

43. Little, "Indian Contribution," 9, 10.

44. Scoresby, *Account of the Artic Regions*, vol. 1, 457.

45. Kurlansky, *Cod*, 24.

46. Ibid., 22.

47. Allen, *Whalebone Whales*, 232.

48. Edwards and Rattray, *Whale Off!* 91. "Whalesteak was cut on the small. A good, solid meat; coarse-grained but tender. You could hardly tell it from beefsteak…Years ago, Grandfather Edwards used to smoke whale meat and keep it for months…Grandmother always kept mince pies made with whale meat on hand." 29, 30.

49. Scoresby, *Account of the Artic Regions*, vol. 1, 176, 463.

50. Goode, *Fisheries*, Section I, 13.

51. Robert Weir on the whaleship *Clara Bell* in 1855. From Oliver, *Saltwater Foodways*, 180.

52. Cahoon, "Captain Stull," 28–29.

53. Oliver, *Saltwater Foodways*, 180.

TECHNIQUES OF HUNTING WHALES

54. Little, "Indian Contribution," 1.

55. Ibid., 54.

56. *Mourt's Relation*, vol. 9, 36. Actually, at least one whale was killed by a musket. "1722, September 3—Court of Admiralty to be held in Boston to adjudicate a drift whale found floating near the Brewsters [islands in Boston harbor] and towed ashore in August…Upon cutting it up, a musket ball was found in the carcass, that had doubtless been fired into it and had caused its death." Allen, *Whalebone Whales*, 154.

57. Starbuck, *History of the American Whale Fishery*, 7, 8. "It may be interesting…to learn, as we do from an ancient chronicle before us, that the first person who killed a whale upon this coast, was named William Hamilton…in early life settled on Cape Cod whence he removed to Rhode Island, he being persecuted for killing a whale by the inhabitants of the Cape, as one who dealt with evil spirits. Mr. Hamilton died in Connecticut in 1746 at the advanced age of 103 years." He was probably the oldest son of Benjamin Hammond (also spelled Hamon, Hamilton and Hambleton). Otis, *Genealogical Notes*, vol. 2, 67, 68.

58. Dow, *Whale Ships*, 7, 8.

59. Scoresby, *Account of the Artic Regions*, vol. 2, 173.

60. Trayser, *Barnstable*, 326–27.

61. McLaughlin, *Proprietors of Barnstable*, 130.

62. Kittredge, *Barnstable*, 19–20.

63. This land was now owned by Ned Handy and his deed called this area "Try Yard Meadow." Barnstable Registry of Deeds, Book 11952, 126.

64. Trayser, *Barnstable*, 325.

65. Yarmouth Proprietors Records, 154. Proprietors meeting of July 1, 1713.

66. Thomas Prince Howes, letter to the *Yarmouth Register*, February 3, 1860, 1.

67. Deyo, *History of Barnstable County*, 155.

68. Ibid., 529.

69. Echeverria, *History of Billingsgate*, 95.

70. Deetz and Deetz, *Times of Their Lives*, 253.

71. Philbrick, *Abram's Eyes*, 155.

72. Rich, "Tavern in the Town."

73. Echeverria, *History of Billingsgate*, 97.

74. Snow, *Pilgrim Returns*, 102. Snow seldom cited sources of his information.

75. Rich, *Truro*, 110.

76. Little, "Indian Contribution," 21.

77. Douglas-Lithgow, *Nantucket*, 107–08.

78. Little, "Indian Contribution," 19.

79. Simpson and Simpson, *Whaling on the North Carolina Coast*, 20.

80. Gorham, *Wast Book*. Gorham was a poor speller. He probably meant to write "Waste Book," a day book that sometimes included letters and correspondence

81. Digges, *Cape Cod Pilot*, 33–34.

82. Lowe, *Nauset*, 31.

83. Stellwagen National Marine Sanctuary, "History of Whaling on Stellwagen Bank," 2. This source also calls the whaleboats "flat bottomed," quoting J.P. Proulx, *Whaling in the North Atlantic* (Ottawa: Minister of the Environment, 1986), 61, but Proulx cites no sources for this information. It is not credible evidence. Perhaps he combined the Committee on Transports negotiation in 1712 for purchasing "flat bottomed boats and whaleboats" (Acts and Resolves of MA, vol. 9, chapter 16 of laws of 1711, 178).

84. Simpson and Simpson, *Whaling on the North Carolina Coast*, 45.

85. Little, "Indian Contribution," 38–41.

86. Vickers, *Maritime Labor*, 153. Justin Winsor, writing in 1849, mentioned that during the American Revolution, in 1775, a regiment went to Sandwich by whaleboat. "Converting their blankets into sails, they reached Sandwich about one o'clock." This indicates that sails were not always part of the boat's "craft" at that time.

87. Hawes, *Whaling*, 72.

88. Calendar of State Papers, vol. 24, no. 604, 402.

89. MA Historical Society Proceedings, vol. 43, 507.

90. Smith, *History of Chatham*, 162–63.

91. Acts and Resolves of MA, vol. 9, chapter 77 of laws of 1722, 187.

92. Ibid., vol. 9, chapter 140 of laws of 1722, August 11, 1722, 209.

93. Ibid., vol. 9, chapter 251 of laws of 1722, December 28, 1722, 245.

94. Ibid., vol. 9, chapter 282 of laws of 1722, 255.

95. Paine, *History of Harwich*, 212.

96. Acts and Resolves of MA, vol. 9, chapter 110, 471.

97. Ibid., vol. 9, chapter 307, 540.

98. Ibid., vol. 9, chapter 143, 631.

99. Gorham, *Wast Book*, 4.

100. Ibid., 6.

101. Ibid., 12.

102. Ibid., 16.

103. Waters, *Otis Family*, 101.

104. Ibid., 102.

105. Ibid.

106. Ibid., 102, 105.

107. Ibid., 106.

108. Church, *History of King Philip's War*, 171: "Their [whaleboat's] swiftness made them more formidable in the pursuit of canoes [carrying enemy Indians] than any other craft then in use."

109. Schneider, *Enduring Shore*, 153.

110. Braginton-Smith and Oliver, *Port on the Bay*, 12. The word canvas describes a stiff, woven cloth of flax or hemp.

111. McClellan, *American Costume*, 230.

112. Edwards and Rattray, *Whale Off!*, 59.

113. The harpoon line (warp) could be purchased, as evidenced by an ad in the *Boston News-Letter* of December 5, 1723.

114. Barnstable Probate Court records, vol. 2, 48.

115. Thomas Lytle, author of Harpoons and Other Whalecraft, wrote on his website at www.whalecraft.net that Clifford Ashley in his book *The Yankee Whaler* identified the start of fastening the whaleboat to the whale between 1761 and 1782. This court document established the date at least forty years earlier.

116. The term "Nantucket sleigh ride" was created by the literary circles of the 1870s. The authors have found no evidence that early whale fishermen used this term.

117. Edwards and Rattray, *Whale Off!*, 92–93.

118. Obed Macy, quoted in Philbrick, *Away Off Shore*, 71.

119. Scoresby, *Account of the Artic Regions*, vol. 1, 460, 461, 463.

120. Barnstable Probate Court Records, vol. 2, 48.

121. Simpson and Simpson, *Whaling on the North Carolina Coast*, 43.

122. Edwards and Rattray, *Whale Off!*, 93.

123. Vol. 1, Province Laws of 1692–93, chapter 17, 49.

124. Scoresby, *An Account of the Artic Regions*, vol. 1, 176.

125. The articles are by Webb, "Trying Out Whale Oil," and a document by Tiffney, "Modern Trying Out."

126. Barnstable County Registry of Deeds, Book 11952, 126. Property owned at this time by Ned Handy of Barnstable.

127. Reid, *Dennis, Cape Cod*, 47.

128. Rich, *Truro*, 233.

129. Douglas-Lithgow, *Nantucket*, 107–08.

130. Stackpole, *Sea Hunters*, 22.

131. Banks, *History of Martha's Vineyard*, 433.

132. Schneider, *Enduring Shore*, 152.

133. Little, "Indian Contribution," 31–33.

A CHRONOLOGICAL LOOK AT SHORE WHALING

134. *Records of the Governor and Company of Massachusetts Bay*, vol. 1, 8, 257.

135. Dow, *Whale Ships*, 9. Plymouth records may not be complete. "In September, 1658, the General Court for the first time ordered the laws which before had been unpublished to be revised and published. This order was executed by the Secretary." (Baylies, *Historical Memoir*, part II, 73) Laws regarding whaling may have been removed. A similar occurrence took place in Barnstable.

136. *Records of the Governor and Company of Massachusetts Bay*, vol. 4, part 2, 191.

137. Starbuck didn't mention this law. His first mention of a specific Plymouth Colony regulation was in 1661.

138. Plymouth Colony Records Laws, vol. 11, 61 (11/PCR/61).

139. 11/PCR/66/

140. 3/PCR/195/

141. Shurtleff, *Records of Plymouth Colony*, 94.

142. 11/PCR/60. Barrels holding liquids needed staves of white oak and were often up to an inch thick. Barrels for dry goods had thinner staves and were not necessarily made of oak. Iron hoops for barrels weren't in general use until after the American Revolution. Whale oil barrels used chestnut or hickory hoops.

143. King, *Cape Cod*, 206.

144. Court Order, June 6, 1654, 3/PCR/ 53.

145. Barnstable Town Records, vol. 1, 1. The records were cleansed again in 1658 and probably after that. An index of Barnstable town records, completed by Mary Lovell in 1895, makes no mention of whaling.

146. Sandwich Town Meeting Records, vol. 1, 1A, 2.

147. Ibid., vol. 1, 2.

148 Ibid., vol. 1, 3.

149. Edgartown Records, vol. 1, 149.

150. Banks, *History of Martha's Vineyard*, vol. 1, 431.

151. Sandwich Town Records, vol. 1, 15.

152. Ibid., vol. 1, 19.

153. Shurtleff, *Records of Plymouth Colony*, 93.

154. 8/PCR/99.

155. 8/PCR/101.

156. 8/PCR/102.

157. June 13, 1660, Plymouth Court "more due to the countrey in oyle att Sandwich and Yarmouth 03:4:0." 8/PCR/101.

158. 4/PCR/99, Court Orders.

159. 7/PCR/106.

160. Eastham Town Records, LDS microfilm #907350.

161. Judging from records, the Smiths were one of the tougher and more combative families on Cape Cod. There were several Smiths involved in whaling during this period. Included were two Ralphs, two Samuels, a Joseph, a Josiah and a Thomas. Samuel, son of Ralph, served as constable of Eastham in 1670 and was sued for abuse of his duties in that position. In 1682, Thomas Clark Sr. of Plymouth sued Samuel Smith of Eastham for unjustly detaining profits of a Cape Cod fishing venture. In 1686, Samuel Smith and John Mayo of Eastham were charged with netting mackerel at Cape Cod in violation of court order. *Mayflower Families*, 27.

162. William Walker served as excise officer, highway surveyor, tithing man and constable at Eastham. On March 3, 1662/23, Ralph Smith was fined for striking William Walker during a dispute over a whale. Smith's son Samuel was fined the same day for saying that he could find it in his heart to thrust a pen into William Walker. *Mayflower Families*, 17.

163. Eastham Town Records, LDS microfilm #907350.

164. Goodwin, *Pilgrim Republic*, 603. Some oil was accounted for, as on June 10, 1661, the treasurer's account mentioned "oyle resting to the countrey att Eastham 1:06:00." Plymouth Colony records, 104.

165. LDS microfilm, #907350.

166. Paine, *History of Harwich*, 402.

167. King, *Cape Cod*, 207. The total proposition is in 4/PCR/6.

168. PCR 1661-2; 206.

169. Trayser, *Barnstable*, 324–25. Trayser assigned the date of 1651 to this quotation, when in fact it was ten years later.

170. 4/PCR/9 Court Orders. Some authors rely on the myth created by Starbuck, 6–7, "The colonial government claimed a portion, a portion was allowed to the town, and the finder, if no other claimant appeared to dispute his title, might presume to claim the other third." Starbuck generally did a better job researching early whaling.

171. 11/PCR/132-5.

172. Thoreau, *Cape Cod*, 54.

173. Sandwich Town Records, vol. 2, 31–32.

174. Early, *And This Is Cape Cod!*, 25.

175. Lowe, *Nauset*, 31.

176. Smith, *History of Chatham*, 84.

177. Little, "Probate Records of Nantucket Indians," 27.

178. Barnstable Town Records, vol. 1, 83.

179. Ibid., vol. 1, 180.

180. Deed owned by John Braginton-Smith.

181. Court document owned by John Braginton-Smith.

182. 2/PCR/17.

183. Plymouth Colony Wills, vol. 3, 32–36.

184. Deed owned by John Braginton-Smith.

185. Rich, *Truro*, 88.

186. *New England Historical and Genealogical Record*, 1855, vol. 9, 44.

187. Allen, *Whalebone Whales*, 54.

188. 11/PCR/207.

189. Records of Plymouth Colony, 35.
190. Court Orders of Plymouth, vol. 5, 97.
191. Banks, *History of Martha's Vineyard*, 432.
192. Emerson, *History of Nashon Island*, 93.
193. Stackpole, *Sea Hunters*, 22.
194. Macy, *History of Nantucket*, 28.
195. Dow, *Whale Ships*, 9.
196. Starbuck, *History of the American Whale Fishery*, 8.
197. Felt, *Annals of Salem*, 223–4. The description "whale voyages at Cape Cod" referred to the area of Truro and Provincetown.
198. *New England Historical and Genealogical Register*, July 1965, 168.
199. Sandwich Town Records, vol. 1, 51.
200. Ibid., vol. 1, 51.
201. LDS microfilm, #907350. Eastham Town Meetings, vol. 1, 1654–1798.
202. LDS microfilm, Yarmouth Town Records.
203. Yarmouth Town Meeting Records, February 4, 1679. LDS microfilm. This is the first formal Yarmouth whaling regulation still in existence.
204. Hawes, *Ancestors and Descendants*, 147.
205. 8/PCR/165.
206. Echeverria, *History of Billingsgate*, 95.
207. American Antiquarian Society archival document.
208. Mass. Col. MSS Treasury, iii, 80.
209. Weckler, "Cape Cod Shore Whaling."
210. 6PCR/251–52. The names of the viewers were published before the law itself.
211. Yarmouth Town Records.
212. 2/Probate Court Records/67.
213. Yarmouth Town Records.
214. Vickers, *Maritime Labor*, 170.
215. Ibid., 172.
216. Philbrick, *Abram's Eyes*, 149. Philbrick implies that the Indians did shore whaling from these spots before the whites took over.
217. Starbuck, *History of the American Whale Fishery*, 17.
218. Warden, *Boston*, 13.
219. Ibid., 17–18.
220. Dow, *Whale Ships*, 16.
221. Allen, *Whalebone Whales*, 131.
222. Cotton Mather's diary, 379.
223. Sandwich Town Records, vol. 2.
224. Ibid.
225. Ibid.
226. 3/Probate Court/80.
227. Handy and Kintzing, "Our Month on Sandy Neck," 2.
228. Waters, *Otis Family*, 51.
229. 3/Probate Court/256. Gorham was a whaleman. One would suppose that it was an indenture.
230. Otis, *Genealogical Notes*, vol. 1, 417.
231. Waters, *Otis Family*, 51–53.
232. Kittredge, *Barnstable*, 19–20.
233. Barnstable Proprietors Records, 126–27.

234. Einstein, *Ebb and Flow*, 127.
235. Allen, *Whalebone Whales*, 133.
236. Probate Court Records.
237. Yarmouth Proprietors Records, 154.
238. Swift, *History of Old Yarmouth*, 210.
239. 3/Probate Court/226.
240. Document owned by John Braginton-Smith.
241. 3/Probate Court/219.
242. Rich, *Truro*, 92.
243. 2/Probate Court/59–60.
244. Deyo, *History of Barnstable County*, 924.
245. Kittredge, *Mooncussers*, 175. A picture is included.
246. Echeverria, *History of Billingsgate*, 37.
247. Province Laws, vol. 3, chapter 119, Acts of 1706–07, 207.
248. Province Laws, Notes about Resolves, vol. 3, 657–60.
249. Ibid., vol. 3, 659.
250. Echeverria, *History of Billingsgate*, 96–97.
251. Ibid., 97.
252. Deyo, *History of Barnstable County*, 926.
253. Echeverria, *History of Billingsgate*, 37.
254. Kinkor, "Pirates of Race Point," 77.
255. Ibid., 79.
256. Freeman, *History of Cape Cod*, 342.
257. Smith, *History of Chatham*, 178.
258. Ibid., 148–49.
259. Ibid., 161–62.
260. Little, "Indian Contribution," 30.
261. Stackpole, *Sea Hunters*, 18.
262. Edgartown Records, vol. 1, 107.
263. Stackpole, *Sea Hunters*, 22.
264. Elizabeth Little did extensive study of woodlands of Nantucket at the time of arrival of the English settlers.
265. Douglas-Lithgow, *Nantucket*, 136.
266. Two authors relate this: Lowe, *Nauset*, 26, and Pratt, *History of Eastham*, 36.
267. Tisbury Town Records, 19.
268. Deyo, *History of Barnstable County*, 923.
269. Rich, *Truro*, 88.
270. Yarmouth Town Records.
271. Barnstable Town Proprietors Records, 121.
272. Echeverria, *History of Billingsgate*, 37.
273. Acts and Laws, 233.
274. New England Historic Genealogical Society, CD-Rom.
275. Massachusetts Acts and Resolves III, 339–40, 361–62.
276. Echeverria, *History of Billingsgate*, 114.
277. True, *Whalebone Whales*, 69.
278. Historical Society of Old Yarmouth archives.
279. Otis, *Genealogical Notes*, vol. 1, 400.
280. Document owned by John Braginton-Smith.
281. Document owned by John Braginton-Smith.

282. Otis, *Genealogical Notes*, 430.
283. Document from E-bay (Early American Inventory #15613, June 27, 2002).
284. Allen, *Whalebone Whales*, 155.
285. Historical Society of Old Yarmouth archives.
286. Reid, *Dennis*, 166.
287. Ibid., 186.
288. Allen, *Whalebone Whales*, 306.
289. Paine, *History of Harwich*, 220.
290. Echeverria, *History of Billingsgate*, 94–95.
291. Diary of Moses Paine, 105–06.
292. Snow, *Pilgrim Returns*, 101–02. Probably copied from Shebnah Rich.
293. Document owned by John Braginton-Smith.
294. Whalen, *Truro*, 114–15.
295. Kittredge, *Cape Cod*, 170.
296. Rich, *Truro*, 237.
297. Rich, "Tavern in the Town."
298. *Boston News-Letter*, April 21, 1737.
299. Deyo, *History of Barnstable County*, 965–66.
300. Document owned by John Braginton-Smith.
301. Smith, *History of Chatham*, 268.
302. Ibid., 269.
303. *Boston News-Letter*, February 12, 1730.
304. Smith, *History of Chatham*, 163 footnote.
305. Moses Brown, from the Mark Coffin Book, 96. Owned by Nantucket Antiquarian Society.
306. Little, "Indian Contribution," 16.
307. American Antiquarian Society, Worcester, MA.
308. Banks, *History of Martha's Vineyard*, 435.
309. Ibid.

DECLINE OF SHORE WHALING AND RISE OF BLACKFISHERIES

310. Dow, *Whale Ships*, 15.
311. Elizabeth Little estimated the high point for shore whaling occurred in 1710 for Long Island, 1715 for Delaware and Cape Cod and 1730 for Nantucket. Little, "Indian Contribution," 30.
312. Simpson and Simpson, *Whaling on the North Carolina Coast*, 10.
313. Diary of Moses Paine.
314. Starbuck, *History of the American Whale Fishery*, 33.
315. Paine, *History of Harwich*, 220. From Benj Bangs diary, reported in Shay and Shay, *Sand in Their Shoes*, 180.
316. Paine, *History of Harwich*, 220.
317. Ibid.
318. Ibid.
319. Trayser, *Barnstable*.
320. Reid, *Dennis*, 186.
321. Rich, *Truro*, 246.
322. Paine, *History of Harwich*, 220.
323. Deyo, *History of Barnstable County*, 791.
324. Deetz and Deetz, *The Times of Their Lives*, 248.

325. Yarmouth Town Clerk notes, 1.

326. Trayser, *Barnstable*, 326–27.

327. Massachusetts Historical Society Collections, 199.

328. Rich, *Truro*, 377.

329. Thoreau, *Cape Cod*, 144.

330. *New Bedford Mercury*, April 2, 1841 34, no. 40 (New Bedford Whaling Museum vertical file).

331. Swift, *Cape Cod*, 271.

332. Allen, *Whalebone Whales*, 136.

333. Ibid., 137.

334. Ibid.

335. Rich, *Truro*, 114.

336. *Yarmouth Register*, July 6, 1855.

337. Ibid., July 20, 1855.

338. Thoreau, *Cape Cod*, 141–45.

339. *Yarmouth Register*, September 14, 1855.

340. Allen, *Whalebone Whales*, 137.

341. Truro Historical Society notation at museum.

342. Kittredge, *Mooncussers*, 174.

343. Deyo, *History of Barnstable County*, 806.

344. Goode, *Fisheries*, 235.

345. Kittredge, *Mooncussers*, 184.

346. Goode, *Fisheries*, 12.

347. Allen, *Whalebone Whales*, 227.

348. Ibid., 228.

349. Stellwagen Bank National Marine Sanctuary, website, 3.

350. Goode, *Fisheries*, 13.

351. Vuilleumier, *Town of Yarmouth*, 55.

352. Deyo, *History of Barnstable County*, 791.

353. Allen, *Whalebone Whales*, 228.

354. Cahoon, "Captain Stull," 29.

355. Allen, *Whalebone Whales*, 229.

356. Ibid., 230.

357. Ibid.

358. Ibid.

359. Cahoon, "Captain Stull," 29.

360. Ibid.

361. Kittredge, *Mooncussers*, 179.

362. *Yarmouth Register*, November 9, 1918.

363. Kittredge, *Mooncussers*, 175.

364. Ibid., 174.

365. Digges, *Cape Cod Pilot*, 41.

366. Photograph of John Braginton-Smith.

367. Quinn, *Shipwrecks*, 210.

INDIANS AND SHORE WHALING

368. Allen, *Whalebone Whales*, 146; also True, *Whalebone Whales*, 35, 44.

369. True, *Whalebone Whales*, 21.

370. Little, "Indian Contribution," 1.

371. Stackpole, *Sea Hunters*, 16.

372. Forman, *Early Nantucket*, 13.

373. Starbuck, *History of American Whale Fishery*, 6.

374. Allen, *Whalebone Whales*, 145; Massachusetts Historical Society Collections, Series 1, vol. 3, 224.

375. Allen, *Whalebone Whales*, 151.

376. Little and Andrews, *Drift Whales at Nantucket*, 18.

377. Province Laws, Notes about Resolves, vol. 3, 657–60.

378. Little and Andrews, *Drift Whales at Nantucket*, 23.

379. Ibid., 19.

380. Stackpole, *Sea Hunters*, 22.

381. Deyo, *History of Barnstable County*, 924.

382. Massachusetts Historical Society Collections, 160.

383. Vickers, *Maritime Labor*, 103.

384. Segel and Pierce, *Wampanoag*, 90.

385. Ibid., 13.

386. Lowe, *Nauset*, 72.

387. Ibid., 31.

388. Smith, *History of Chatham*, 266.

389. Massachusetts Historical Society Publications, "Eastham," 175.

390. Schneider, *Enduring Shore*, 154–57.

391. Little, "Indian Contribution," 34.

392. Allen, *Whalebone Whales*, 166.

393. Vickers, *Maritime Labor*, 170.

394. Ibid., 172.

395. Ibid., 105.

396. Ibid., 105; Acts and Resolves, vol. 2, 159, 289, 438, 583, 668, 705.

397. Segel and Pierce, *Wampanoag*, 13.

398. Vickers, *Maritime Labor*, 169.

399. Kittredge, *Barnstable*, 155.

400. Vickers, *Maritime Labor*, 184.

401. Reid, *Dennis*, 143.

402. Barber, *Cape Cod's Early Quakers*, 70.

403. Kittredge, *Barnstable*, 156.

404. Acts and Resolves of Massachusetts, vol. 1, chapter 11 of laws of 1703.

405. Yarmouth Town Records.

JACOBUS LOPER AND ICHABOD PADDOCK

406. O'Callaghan, ed., *Colonial History of New York*, vol. 17, Curacao Papers. Facts, if not footnoted, are from Loper genealogist Chuck Solomon.

407. O'Callaghan, ed., *Colonial History of New York*, vol. 1, 358.

408. *East Hampton Star*, September 16, 1965, "The Great Whale Debate Continues," 7.

409. Starbuck, *History of American Whale Fishery*, 12.

410. This information is also in the journal of the Kittredge Maritime Research Center 2, no. 1, *The Cape Cod Mariner* (Summer 1990), 3.

411. Edwards and Rattray, *Whale Off!*, 178. An entire chapter is titled "James Loper," but does little to clear the problems. They did no research on Cape Cod and state that whaling started on Cape Cod in 1670 (176).

412. Gorham, *Wast Book*, 22. Respected author Donald Trayser misread the name and called him "Lopez."

413. In a lengthy footnote on pages 16 and 17, Starbuck argues against the names Jacobus and James being the same person.

414. Letter to Alexander Starbuck, April 3, 1876, from Department of Historical Records of New York. Nantucket Historical Association.

415. 6/PCR/203–4.

416. From Nantucket History (Collection 580 #35, Book 12, 1–3; summary note 520), which quotes State Archives 1–60, Book 12, 5. It is also mentioned by Fells in *Annals of Salem*, 223.

417. *East Hampton Star*, September 16, 1965, 7.

418. Ibid. 7

419. Ninth Report of the Record Commissioners of Boston, 1630–99, 180.

420. Fairburn, *Merchant Sail*, vol 2. 981.

421. Philbrick, *Away Off Shore*, 65.

422. Bliss, *Quaint Nantucket*, 105. No date is given for this incident and nothing was found about Latham Gardner. He is not mentioned by Robert Leach.

BIBLIOGRAPHY

Four treatises have been written about various aspects of shore whaling, but none look at its early history in the Cape Cod area. The most thoroughly researched is Elizabeth Little's *Nantucket Algonquian Studies* 8, "The Indian Contribution To Along-Shore Whaling At Nantucket," Nantucket Historical Association, 1981. Using primary source materials, the articles she has written cover the Indian contribution to Nantucket shore whaling. We have not included much of her research and suggest that everyone interested in shore whaling on Nantucket read her articles. Sadly, she does not cover areas beyond Nantucket.

The second is *Whale Off*, by Edwards and Rattray. Written in the 1930s, its strength is its fine accounts of shore whalemen still operating off Long Island before the turn of the twentieth century. Its weakness is the lack of research where it relates to shore whaling history, especially when discussing James (Jacobus) Loper.

The third is *Whaling on the North Carolina Coast*, by Marcus and Sallie Simpson. It covers North Carolina from the seventeenth century to the present, and does include those New Englanders who traveled there to go whaling.

The fourth is "Whaling Days in New Jersey," a chronicle by Barbara Lipton for the *Newark Museum Quarterly*. It covers only the New Jersey area.

MANUSCRIPTS, DOCUMENTS AND OTHER SOURCES

Acts and Laws of His Majesty's Province of the Massachusetts Bay in New England. B. Green, 1726.

American Antiquarian Society of Worcester, MA, archival documents.

Barber, Laurence Barber. Early information about Cape Cod Quakers and the Yarmouth Preparative Meeting.

Benjamin Bangs of Harwich diaries. New England Historic Genealogical Society. Cape Cod town documents from microfilm taken by the LDS and town archives.

Commonwealth of Massachusetts, Harbor and Land Commission, Atlas of Boundaries of Towns in Barnstable, Dukes and Nantucket Counties. 1907, #59.

Cotton Mather's diary. Massachusetts Historical Society Collection, seventh series, vol. 8.

Diary of Moses Paine, 1695–1764. *New England Historical and Genealogical Register* 44 (1900).

Goode, George Brown. *The Fisheries and Fishery Industries of the United States.* Vol. 2. Washington, D.C.: Government Printing Office, 1884–87.

Handy, Susie, and Jenny Kintzing. "Our Month on Sandy Neck." June 1972. Unpublished manuscript in possession of Ned Handy.

Headlam, C., ed. Calendar of State Papers, Colonial Series, America and West Indies, vol. 24. London: His Majesty's Stationery Office, 1922.

Historical Society of Old Yarmouth archives.

Massachusetts Historical Society Collections, first series, vol. 2 and vol. 8, 1802; second series, vol. 9 (includes *Mourt's Relation* in two separate articles, and Zaccheus Macey's "Account of Nantucket").

McLauglin, James F., ed. Records of the Proprietors of the Common Lands in the Town of Barnstable, Massachusetts, 1703–1795. Barnstable Planning Board, 1935; revised edition with index by Andrea Leonard, Bowie, MD: Heritage Books, 1935.

Nantucket Historical Association archives—Obed Macy Journal, Notebook A, Folder 18; Mark Coffin Book—1834; Charles Stubbs Diary, Folder 69-1; Henry Barnard Worth Collection, Collection 35, Book 12.

New England Historic Genealogical Society. CD-Rom, Town of Barnstable, MA Records.

———. *The New England Historical and Genealogical Register.*

Ninth Report of the Record Commissions—Births, Baptisms, Marriages and Deaths, 1630–1699. Boston, 1883.

O'Callaghan, E.B., ed. *Documents Relating to Colonial History of New York.* Albany, 1855.

Peleg Folger's journal, 1753. Nantucket, Atheneum.

Plymouth Colony records.

Province charter for Massachusetts Bay.

Province laws of Massachusetts Bay.

Shurtleff, Nathaniel, ed. Records of the Governor and Company of the Massachusetts Bay in New England. Boston, 1853.

————. Records of Plymouth Colony, 1633–1689. 1857.

Swift, Wm. S, arr. Records of the Town of Tisbury, 1669–1864. Boston, 1903.

Tiffney, Wesley N., Jr. "A Modern Trying Out—Rendering Pilot Whale Blubber in 1983." Typed manuscript.

Van Doren, Mark, ed. *Samuel Sewall's Diary*. New York: Russell & Russell, 1963.

Wast(e) Book belonging to John Gorham of Barnstable. Beginning in Louisbourg, August 28, 1745. Original at Sturgis Library, Barnstable, MA.

BOOKS AND JOURNALS

Allen, Glover M. *The Whalebone Whales of New England*. Boston: Boston Society of Natural History, 1916.

Ashley, Clifford W. *The Yankee Whaler*. Boston: Houghton Mifflin, 1938.

Banks, Charles. *History of Martha's Vineyard, Mass.* 3 vols. Boston: George H. Dean, 1911–25.

Barber, Laurence. *Cape Cod's Early Quakers*. Yarmouth Port, MA: Historical Society of Old Yarmouth, 1999.

Baylies, Francis. *Historical Memoir of the Colony of New Plymouth*. Boston: Hilliard, Gray, Little, and Wilkins, 1820.

Berger, Joseph (Jeremiah Digges). *Cape Cod Pilot*. Provincetown and New York: Modern Pilgrim Press for the Works Progress Administration, 1937.

Bliss, William Root. *Quaint Nantucket*. Boston: Houghton Mifflin, 1896.

Braginton-Smith, John, and Duncan Oliver. *Port on the Bay*. Yarmouth Port, MA: Historical Society of Old Yarmouth, 2001.

Brownell, Robert, Jr., Peter Best and John Prescott, eds. *Right Whales: Past and Present Status*. Boston: New England Aquarium for the International Whaling Commission, 1983.

Butler, Gerald. *The Military History of the Cape Cod Canal*. Charleston, SC: Arcadia Publishing, 2002.

Calloway, Colin G. *After King Philip's War: Presence and Persistence in Indian New England*. Hanover, NH: Dartmouth College, 1997.

Church, Albert Cook. *Whale Ships and Whaling*. New York: Bonanza Books, 1938.

Church, Benjamin. *History of King Philips's War*. Boston: John Kimball Wiggin, Publisher, 1865.

Curfman, Robert Joseph. *The Paddock Genealogy*. Fort Collins, CO: Western Reserve Historical Society, 1977.

Deetz, James, and Patricia Deetz. *The Times of Their Lives—Life, Love, and Death in Plymouth Colony*. New York: W.H. Freeman and Co., 2000.

Derick, Burton N. *The Nickerson Family and the History of William Nickerson*. Chatham, MA: Nickerson Family Association, Inc., 1998.

Deyo, Simeon L. *History of Barnstable County*. 2 vols. New York: Blake, 1890.

Digges, Jeremiah (Joseph Berger). *Cape Cod Pilot*. Provincetown and New York: Modern Pilgrim Press for the Works Progress Administration, 1937.

Douglas-Lithgow, R.A. *Nantucket, A History*. New York: G.P. Putnam's Sons, 1914.

Dow, George F. *Whale Ships and Whaling*. Salem, MA: Marine Research Society, 1925.

Early, Eleanor. *And This is Cape Cod!* Boston: Houghton Mifflin, 1936.

Echeverria, Durand. *A History of Billingsgate*. Wellfleet, MA: Wellfleet Historical Society, 1993.

Edwards, Everett J. and Jeannette E. Rattray. *Whale Off! The Story of American Shore Whaling*. New York: Frederick Stokes Co., 1932.

Einstein, Cheryl (Nourse), comp. *The Ebb and Flow of Life on Sandy Neck*. Privately published. Written by residents of Sandy Neck, 1977.

Emerson, Amelia Forbes. *Early History of Nashon Island*. Boston: Howland & Co., 1981.

Fairburn, William A. *Merchant Sail*. 2 vols. Center Lovell, ME: Fairburn Marine Educational Foundation, 1945–55.

Felt, Joseph B. *Annals of Salem*. Vol. 2. Boston: James Monroe and Co., 1849.

Flayderman, E. Norman. *Scrimshaw and Scrimshanders—Whales and Whalemen*. New Milford, CT: Flayderman & Co.

Forman, Henry C. *Early Nantucket and its Whale Houses*. Nantucket, MA: Mill Hill Press, 1991.

Freeman, Frederick. *History of Cape Cod*. 2 vols. Boston, 1858, reprint Yarmouth Port, MA: Parnassus Imprints, 1965.

Goodwin, John A. *The Pilgrim Republic*. Boston: Tucknor & Co., 1888.

Green, Eugene, and William Sachse. *Names of the Land*. Chester, CT: The Globe Pequot Press, 1983.

Hawes, Charles Boardman. *Whaling*. New York: Doubleday Page & Co., 1924.

Hawes, James W.A.M. *Ancestors and Descendants of Edmond Hawes*. New York: Lyons Genealogical Co., 1914.

Hohman, Elmo Paul. *The American Whaleman*. New York: Longmans, Green and Co., 1928.

Hutchinson, Thomas. *The History of the Colony and Province of Massachusetts Bay from 1691–1750 by Mr. Hutchinson, Lt. Governor*. 2 Vols. Reprinted Cambridge, MA: Harvard University Press, 1936.

Jensen, Albert C. *The Cod*. New York: Thomas Crowell Co., 1972.

Kennedy, Maev. *The History of Archaeology*. New York: Goldalming Surrey, distributed by Quadrillion Press, 1999.

King, H. Roger. *Cape Cod and Plymouth Colony in the Seventeenth Century*. Lanham, MD: University Press of America, 1994.

Kittredge, Henry C. *Barnstable 1639–1939—A Brief Historical Sketch*. Barnstable, MA: Barnstable Tercentenary Committee, 1939.

———. *Cape Cod—Its People and Their History*. 2nd edition, Boston: Houghton Mifflin, 1968.

————. *The Mooncussers of Cape Cod*. Cambridge, MA: Riverside Press, 1937.

Kurlansky, Mark. *Basque History of the World*. New York: Walker and Co., 1999.

————. *Cod*. New York: Penguin Books, 1997.

Langdon, William Chauncey. *Everyday Things in American Life 1607–1776*. New York: Charles Scribners, 1937.

Leach, Robert, and Peter Gaus. *Quaker Nantucket*. Nantucket: Mill Hill Press, 1999.

Little, Elizabeth A., and J. Clinton Andrews. *Drift Whales at Nantucket: The Kindness of Moshup*. Nantucket: University of Massachusetts Field Station, 1980.

Lowe, Alice A. *Nauset on Cape Cod—A History of Eastham*. Provincetown: Shank Painter Printing, 1968.

Lytle, Thomas G. *Harpoons and Other Whale Craft*. New Bedford, MA: Old Dartmouth Historical Society, 1984.

Marine Research Society. *Whale Ships and Whaling*. Publication 10. Salem, MA: Marine Research Society, 1925.

Mayflower Families Through Five Generations. Vol. 6. Plymouth, MA: General Society of Mayflower Descendants, 1992.

McClellan, Elisabeth. *History of American Costume*. New York: Tudor Publishing Co., 1969.

McCordle, Barbara Backus. *New England in Early Printed Maps—1513 to 1800*. 2001.

Melville, Herman. *Moby Dick or the Whale*. New York: Harper & Brothers, 1851.

Miller, Pamela A., ed. *And The Whale Is Ours*. Boston: DR Godine for the Kendall Whaling Museum, 1979.

Norling, Liza. *Captain Ahab Had a Wife*. Chapel Hill: University of North Carolina Press, 2000.

O'Connell, James C. *Becoming Cape Cod—Creating a Seaside Resort*. Durham: University of New Hampshire, 2003.

Oliver, Sandra L. *Saltwater Foodways*. Mystic, CT: Mystic Seaport Museum, 1995.

Otis, Amos. *Genealogical Notes of Barnstable Families*. 2 vols. Barnstable, MA: FB&FP Gross, The Patriot Press, 1888.

Paine, Josiah. *A History of Harwich, 1620–1800*. Yarmouth Port, MA: Parnassus Imprints, 1971.

Philbrick, Nathaniel. *Abram's Eyes—The Native American Legacy of Nantucket Island*. Nantucket: Mill Hill Press, 1998.

———. *Away Off Shore—Nantucket Island and Its People, 1602–1890*. Nantucket: Mill Hill Press, 1994.

Pratt, Reverend Enoch. *A Comprehensive History of Eastham, Wellfleet, and Orleans—1644–1844*. Yarmouth: W.S. Fisher Co., 1844.

Reid, Nancy Thacher. *Dennis, Cape Cod*. Dennis, MA: Dennis Historical Society, 1996.

Reynard, Elizabeth. *This Narrow Land*. Boston: Houghton Mifflin, 1934.

Rich, Shebnah. *Truro—Cape Cod*. Boston: D. Lothrop & Co., 1884.

Schneider, Paul. *The Enduring Shore*. New York: Henry Holt & Co., 2000.

Scoresby, William. *An Account of the Artic Regions and Description of the Northern Right Whale Fishing*. David and Charles reprint of Constable and Co. Ltd., Edinburgh, 1969.

Segel, Jerome D., and R. Andrew Pierce. *The Wampanoag Genealogical History of Martha's Vineyard*. Baltimore: Genealogical Publishing Co., 2003.

Shapiro, Irwin, for the editors of American Heritage. *The Story of Yankee Whaling*. New York: American Heritage Publishing, 1959.

Shay, Edith, and Frank Shay, eds. *Sand In Their Shoes*. Yarmouth Port, MA: Parnassus Imprints, 1979.

Simpson, Marcus B., Jr., and Sallie W. Simpson. *Whaling on the North Carolina Coast*. Raleigh: Historical Publication Center for the NC Department of Cultural Resources, 1990.

Smith, William C. *A History of Chatham, MA*. Chatham, MA: Chatham Historical Society, 1971. Fourth edition, 1992.

Snow, Edward Rowe. *A Pilgrim Returns to Cape Cod*. Boston: Boston Publishing Co., 1946.

Stackpole, Edouard A. *The Sea Hunters—New England Whalemen 1635–1835*. New York: J.B. Lippincott Co., 1953.

BIBLIOGRAPHY

Starbuck, Alexander. *History of the American Whale Fishery*. 1878. Seacaucus, NJ: Castle Books, 1989.

———. *History of Nantucket*. Rutland, VT: Charles E. Tuttle Co., 1969.

State Street Bank and Trust Company. *Whale Fishery of New England*. Boston: Walter Advertising and Printing, 1915.

Stiles Ely, Ben-Ezra. *There She Blows—A Narrative of a Whaling Voyage*. Middletown, CT: Wesleyan University Press, 1971.

Stratton, Eugene Aubrey. *Plymouth Colony: Its History and People 1620–1691*. Salt Lake City: Ancestry Publishing, 1986.

Swift, Charles F. *Cape Cod*. Yarmouth Port, MA: Register Publishing Company, 1897.

———. *History of Old Yarmouth*. Edited by Charles Holbrook Jr., Yarmouth Port, MA: Historical Society of Old Yarmouth, 1975.

Thacher, J. *History of the Town of Plymouth from Its First Settlement in 1620*. Boston: March, Capen, and Lyon, 1832.

Thoreau, Henry David. *Cape Cod*. Arranged with notes by Dudley C. Hunt. New York: Bramhall House, 1951.

Trayser, Donald. *Barnstable, Three Centuries of the Cape Cod Town*. Yarmouth Port, MA: Parnassus Imprints, 1971.

True, Frederick W. *Whalebone Whales of the Western North Atlantic*. Washington, D.C.: Smithsonian Institution Press, 1983.

Turner, Harry B. *Nantucket Argument Settler*. Sixth edition, Nantucket, MA: The Inquirer and Mirror Press, 1946.

Vickers, Daniel F. *Maritime Labor in Colonial Massachusetts: A Case Study of the Essex County Cod Fishery and the Whaling Industry of Nantucket, 1630–1775*. PhD diss., Princeton University, 1981.

Vuilleumier, Marion. *The Town of Yarmouth, Massachusetts, A History 1639–1989*. Yarmouth Port, MA: Historical Society of Old Yarmouth, 1989.

Warden, G.B. *Boston, 1689–1776*. Boston: Little, Brown and Company, 1970.

Waters, John J., Jr. *The Otis Family*. Chapel Hill: University of North Carolina Press, 1968.

Whalen, Richard F. *Truro—The Story of a Cape Cod Town*. Philadelphia: Xlibris Corp., 2002.

Winsor, Justin. *A History of Duxbury, Massachusetts*. Baltimore, 1849: reprinted by Genealogical Publications Co., 1995.

Winthrop, John Esq. *The History of New England, 1630–1649*. Notes by James Savage. Boston: Phelps and Farnham, 1825. Reprinted, New York: Arno Press, 1972, as part of the Research Library of Colonial America.

Young, Alex. *Chronicles of the Pilgrim Fathers of the Colony of Plymouth from 1602 to 1625*. Boston: C.C. Little and J. Brown, 1841.

PERIODICALS AND ARTICLES

Barnstable Patriot.

Boston News-Letter.

Brisbane, Arthur. "Whaling Off Long Island." *Harper's Young People*. February 10, 1885.

Cahoon, Robert H. "Captain Stull and the Blackfish Industry." *Cape Cod Magazine*, 1916, 27–28.

Cape Cod Mariner 2, no. 1. Journal of Kittredge Maritime Research Center. Summer 1990.

Coast Lines. Massachusetts Coastal Zone Management, Boston, MA, Summer 2002 edition.

East Hampson Star.

Kinkor, Kenneth J. "Pirates of Race Point." *Cape Cod Life*, January 1997, 77–83.

Little, Elizabeth A. "The Indian Contribution To Along-Shore Whaling At Nantucket." *Nantucket Algonquian Studies* 8, Nantucket, MA: Nantucket Historical Association, 1981.

———. "Probate Records of Nantucket Indians." *Nantucket Algonquian Studies* 2, Nantucket, MA: Nantucket Historical Association, 1980.

New Bedford Mercury.

New Bedford Standard Times.

Reves, Randall, and Edward Mitchell. "Yankee Whaling for Right Whales in the North Atlantic Ocean." *Whalewatcher* 17, no. 4 (Winter 1983).

Reves, Randall, Jeffrey Breiwick and Edward Mitchell. "History of Whaling and Estimated Kill of Right Whales, *Balaena alacialis*, in the Northeastern United States, 1620–1923." *Marine Fisheries Review* 61, no. 3 (1999): 1–36.

Rich, Earle G. "A Tavern in the Town." *The Owl*, August 24, 1972.

Shoemaker, Elizabeth, ed. *Cape Cod Legends*. Cape Cod Chamber of Commerce, 1925.

Stellwagen Bank National Marine Sanctuary. "History of Whaling on Stellwagen Bank." Site report on internet.

Webb, Robert Lloyd. "Trying-Out Whale Oil: Experimenting With History." *Coastal Journal*, early summer 1985, 62–66.

Weckler, Richard. "Cape Cod Shore Whaling." Kittredge Maritime Research Center, date unknown.

Whale Fishery of New England, printed for State Street Trust Co., Boston.

Yarmouth Register.

INDEX

An index involving seventeenth-, eighteenth- and nineteenth-century documents is difficult to create, due to the numerous ways words and names are spelled by the individual writers. The authors have tried to find every different spelling and include it with the correct word/name.

Visit us at
historypress.net